IMPRESSIONS of the
COTSWOL

Produced by AA Publishing

© Automobile Association Developments Limited 2008

All rights reserved. No part of this publication may be reproduced, stored in
a retrieval system, or transmitted in any form or by any means – electronic,
photocopying, recording or otherwise – unless the written permission of the
publishers has been obtained beforehand.

Published by AA Publishing (a trading name of Automobile Association
Developments Limited, whose registered office is Fanum House, Basing View,
Basingstoke, Hampshire RG21 4EA; registered number 1878835)

ISBN 978-0-7495-5546-7

A03033g

A CIP catalogue record for this book is available from the British Library.

The contents of this book are believed correct at the time of printing. Nevertheless,
the publishers cannot be held responsible for any errors, omissions or for changes in
the details given in this book or for the consequences of any reliance on the
information provided by the same. This does not affect your statutory rights.

Colour reproduction by KDP, Kingsclere
Printed and bound in China by C&C Offset Co Ltd

Opposite: Window detail in Chipping Campden

IMPRESSIONS *of the*
COTSWOLDS

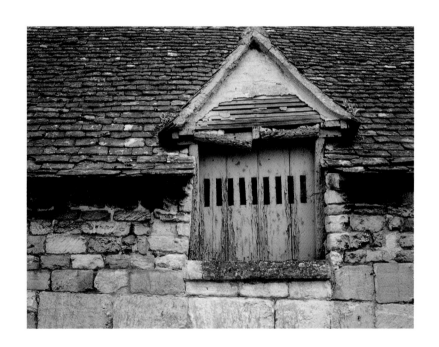

Acknowledgements

The Automobile Association wishes to thank the following photographers, companies and picture libraries for their assistance in the preparation of this book.

Abbreviations for the picture credits are as follows: (AA) AA World Travel Library

3 AA/D Hall; 5 AA/D Hall; 7 AA/S Day; 8 AA/D Hall; 9 AA/S Day; 10 AA/M Birkitt; 11 AA/S & O Mathews; 12 AA/S Day; 13 AA/S Day; 14 AA/S Day; 15 AA/D Hall; 16 AA/H Williams; 17 AA/D Hall; 18 AA/S Day; 19 AA/H Palmer; 20 AA/D Hall; 21 AA/S Day; 22 AA/H Palmer; 23 AA/D Hall; 24 AA/D Hall; 25 AA/H Palmer; 26 AA/D Hall; 27 AA/F Stephenson; 28 AA/W Voysey; 29 AA/D Hall; 30 AA/C Jones; 31 AA/D Hall; 32 AA/D Hall; 33 AA/D Hall; 34 AA/D Hall; 35 AA/A Lawson; 36 AA/K Doran; 37 AA/D Hall; 38 AA/H Palmer; 39 AA/H Palmer; 40 AA/D Hall; 41 AA/D Hall; 42 AA/D Hall; 43 AA/S Day; 44 AA/D Hall; 45 AA/H Palmer; 46 AA/D Hall; 47 AA/S Day; 48 AA/S Day; 49 AA/D Hall; 50 AA/D Hall; 51 AA/D Hall; 52 AA/S Day; 53 AA/D Hall; 54 AA/S Day; 55 AA/S Day; 56 AA/D Hall; 57 AA/D Hall; 58 AA/D Hall; 59 AA/S Day; 60 AA/D Hall; 61 AA/M Short; 62 AA/K Doran; 63 AA/D Hall; 64 AA/S Day; 65 AA/S Day; 66 AA/R Surman; 67 AA/H Palmer; 68 AA/S Day; 69 AA/A Baker; 70 AA/S Day ; 71 AA/H Palmer; 72 AA/C Jones; 73 AA/D Hall; 74 AA/R Ireland; 75 AA/D Hall; 76 AA/S Day; 77 AA/T Souter; 78 AA/D Hall; 79 AA/S Day; 80 AA/S & O Mathews; 81 AA/K Doran; 82 AA/A Baker; 83 AA/S Day; 84 AA/D Hall; 85 AA/K Doran; 86 AA/H Palmer; 87 AA/S Day; 88 AA/R Rainford; 89 AA/S Day; 90 AA/D Hall; 91 AA/M Short; 92 AA/D Hall; 93 AA/S Day; 94 AA/H Palmer; 95 AA/A Baker.

Every effort has been made to trace the copyright holders, and we apologise in advance for any unintentional omissions or errors. We would be pleased to apply any corrections in any following edition of this publication.

Opposite: Poppies add a swathe of red to this summer landscape near Sherborne

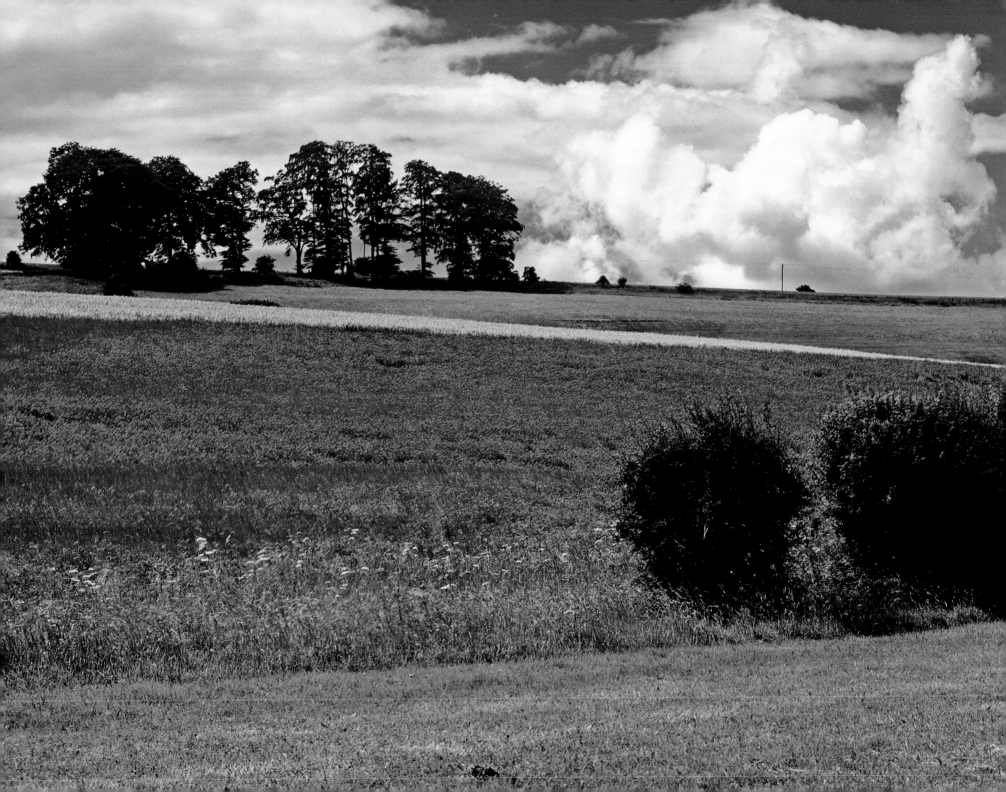

INTRODUCTION

The Cotswolds is officially an Area of Outstanding Natural Beauty (AONB), as the signpost on page 8 makes clear. It's nice to know that even the bureaucrats recognise it, but it doesn't need a sign to prove it. Anyone who has visited knows it, and anyone who hasn't will see from this book that it is one of the most picturesque parts of England.

An AONB is similar to a National Park, and the designation is of value because it offers some measure of protection to the landscape, and to the people who live and work in it. It helps to ensure that the Cotswolds will stay as beautiful in the future as it has been in the past.

One thing abundantly clear from browsing through these photographs is what a timeless place the Cotswolds is. Many show the natural beauty, and in some landscapes there is no evidence of mankind whatsoever. Where people have built houses, they have mostly used the lovely local stone to create homes that are harmonious and pleasing to the eye. One occasional complaint about the Cotswolds is that it is just too perfect, too much like the photo on top of a box of chocolates. All anyone can say to that is that this really is what the Cotswolds looks like.

The Cotswolds is sometimes called the Heart of England, which is not geographically correct. It would probably be more accurate to call it the epitome of rural England. The area known as the Cotswolds is centred on the Cotswold Hills, which are mostly low and rolling with a high point of only 1083 feet (330m) at Cleeve Hill near Cheltenham.

The Cotswolds is spread over six English counties, with variable boundaries. Some say from west of Oxford to the River Severn, though that would add in the city of Bristol. While nearby Bath is usually included, and thought of as 'Cotswolds', the further big city of Bristol definitely isn't. In the north it reaches to Gloucester, Cheltenham and the Vale of Evesham, and in the south to Chippenham and the Thames Valley.

Certain spots in the Cotswolds are almost too popular for their own good. Villages such as Bourton-on-the-Water, Burford, Chipping Campden and Bibury all beg to be seen as the archetypal Cotswold village. They are almost unbelievably beautiful, and it is no surprise that they are often chosen as England's prettiest village, with their attractive old cottages built from the honey-coloured Cotswold stone, rivers or streams flowing gently through, and of course, a few examples of the perfect English pub.

But everyone goes to these places, and they can be overwhelmed by visitors on a sunny English summer day. You will have a better and more personal experience by travelling to some of the lesser-known but equally picturesque places. Try to find the tiny hamlet of Ablington (page 61), and drink some beer from the Uley Brewery in Uley itself (page 65). The several photos of Snowshill in these pages would make anyone want to seek it out, as English nature here definitely takes centre stage.

Or choose a place simply because you like its name. In the Cotswolds it's hard to go far wrong. Who could not want to see the villages of Upper Slaughter and Lower Slaughter, even if you know the name probably means nothing more dramatic than a muddy place? And how can you resist Coln St Aldwyn and Uley Bury? This last shows how timeless these places truly are, as Uley Bury was the site of an Iron Age hill fort some 2500 years ago. It surely wasn't chosen purely for defensive purposes. Even in the Iron Age they knew an Area of Outstanding Natural Beauty when they saw one.

Painswick, with its 11th-century parish church of St Mary

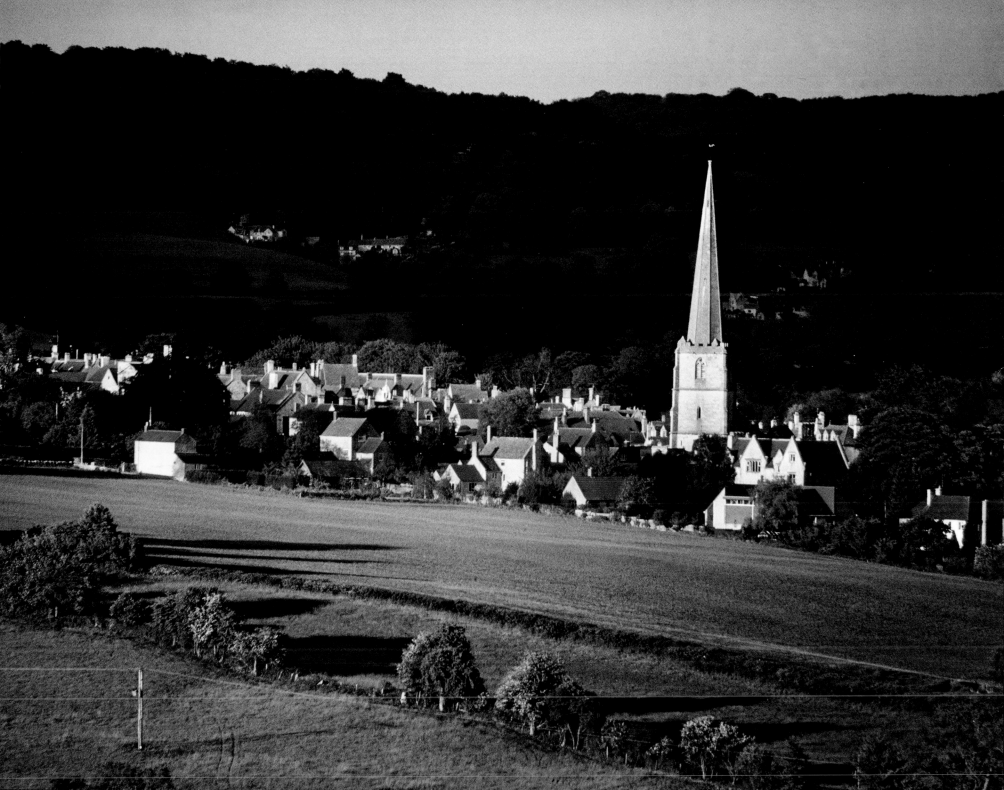

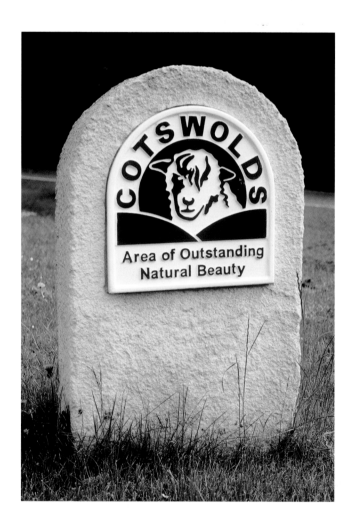

This stone in Burford describes the Cotswolds perfectly
Opposite: The 15th-century tower of the church of St James in Chipping Campden

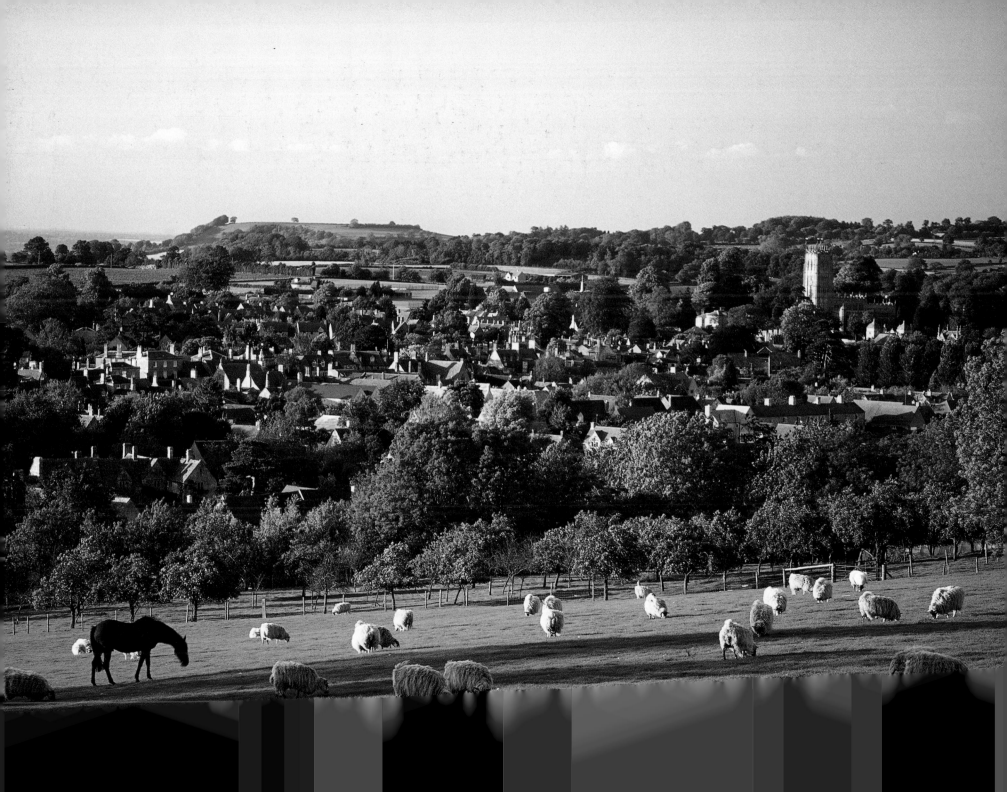

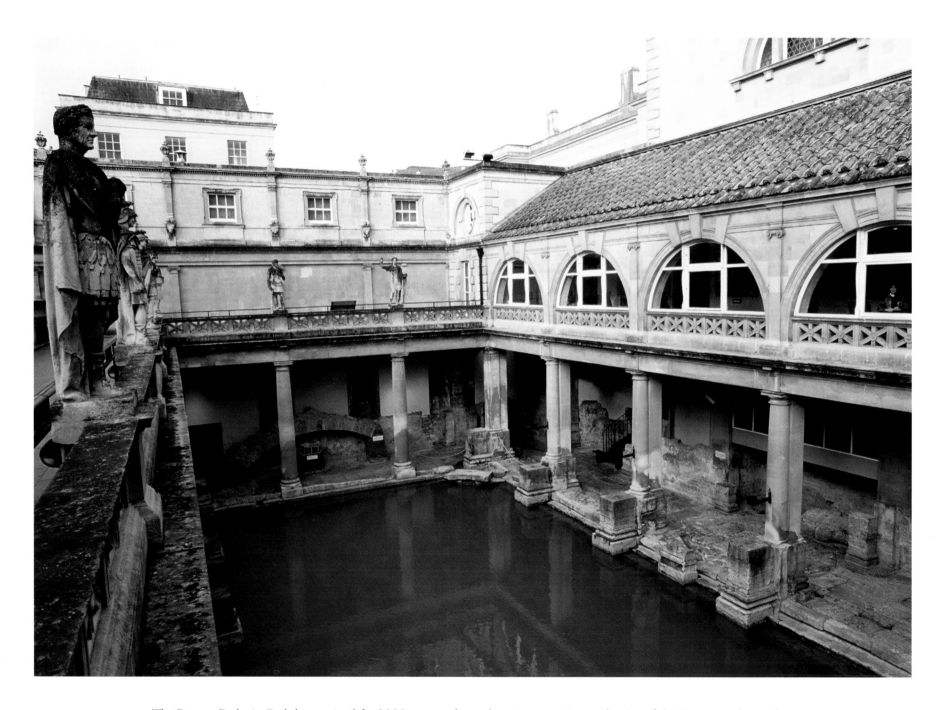

The Roman Baths in Bath have existed for 2000 years and were huge in comparison to the size of the Roman settlement here

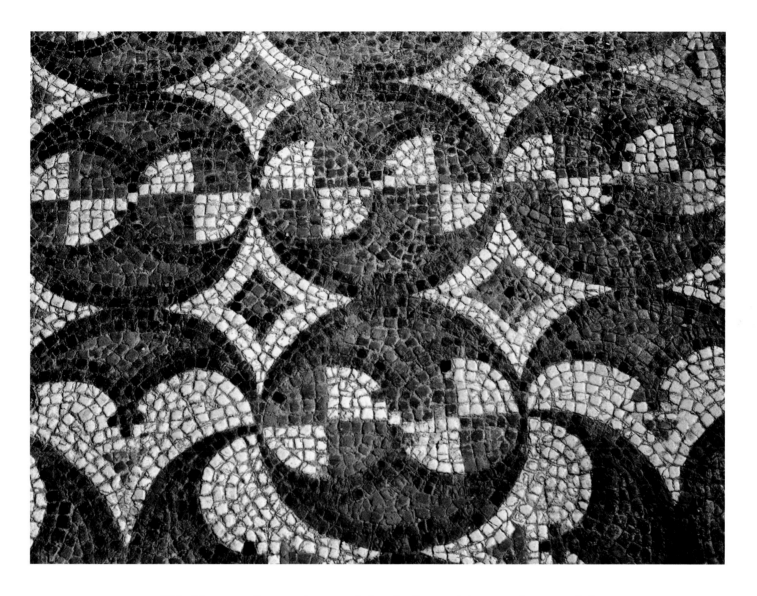

This 4th-century floor mosaic was made from locally quarried stone and once paved the
West Bath-house of Chedworth Roman Villa, near Cheltenham

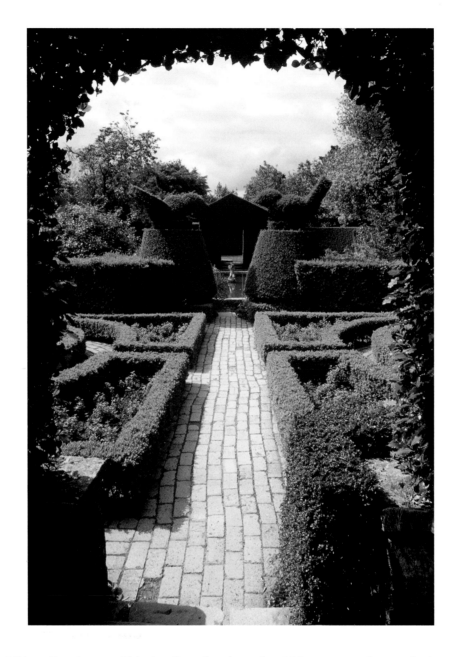

Hidcote Manor Garden in Hidcote Bartrim near Chipping Campden shows that 20th-century gardens can be just as beautiful as older creations
Opposite: William Morris described Bibury as 'the most beautiful village in England', and these 14th-century cottages in Arlington Row show why

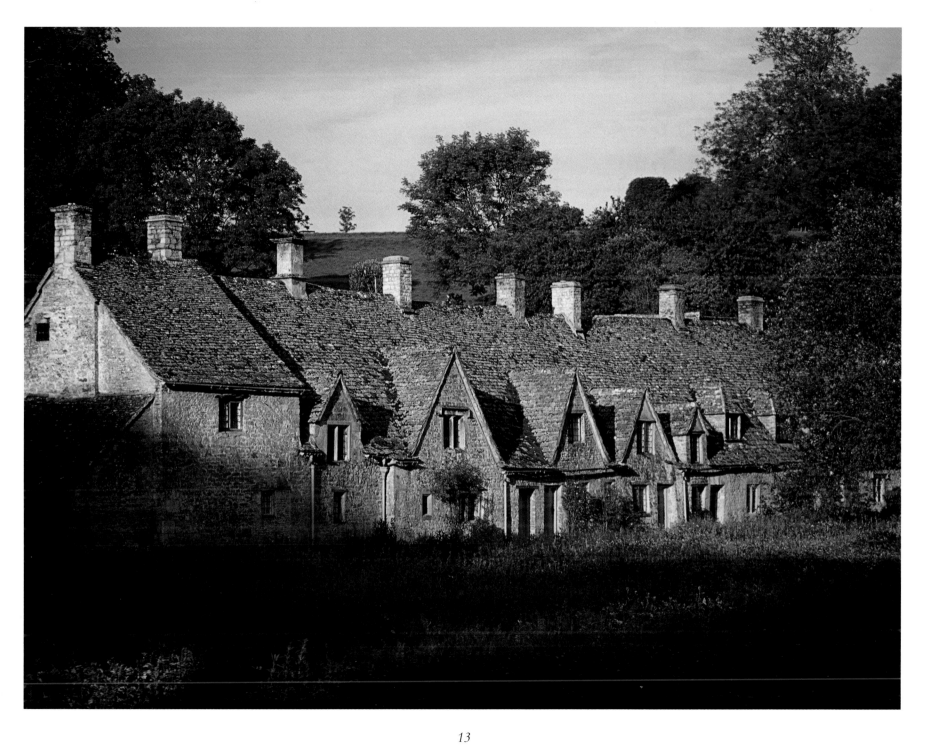

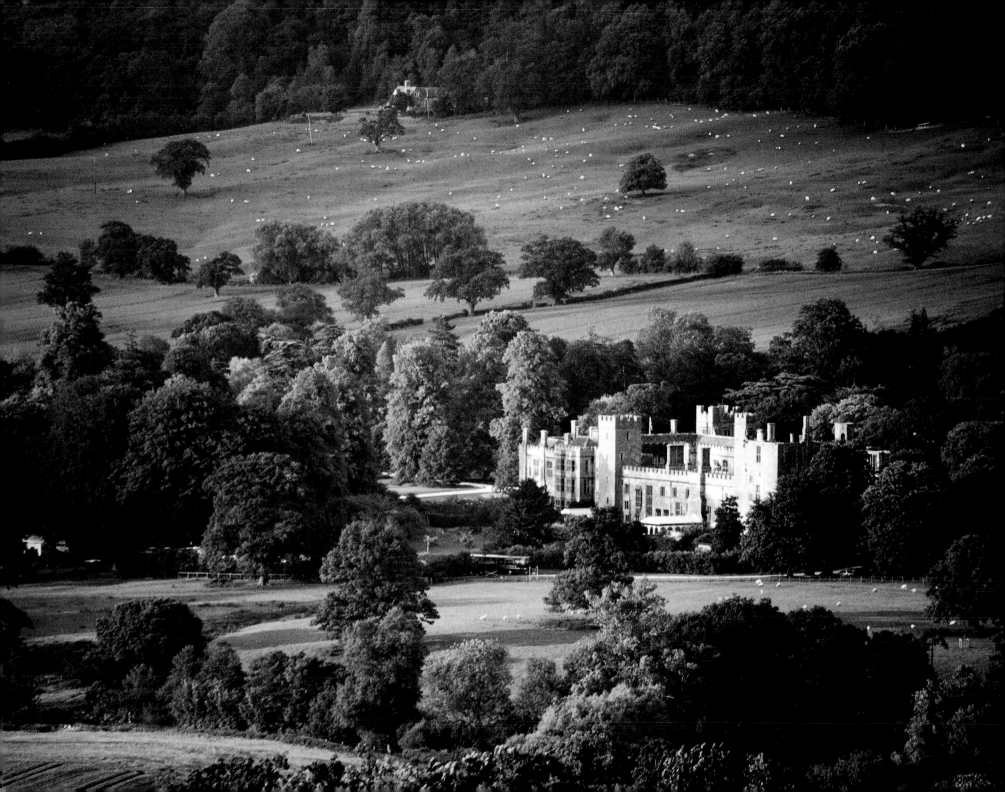

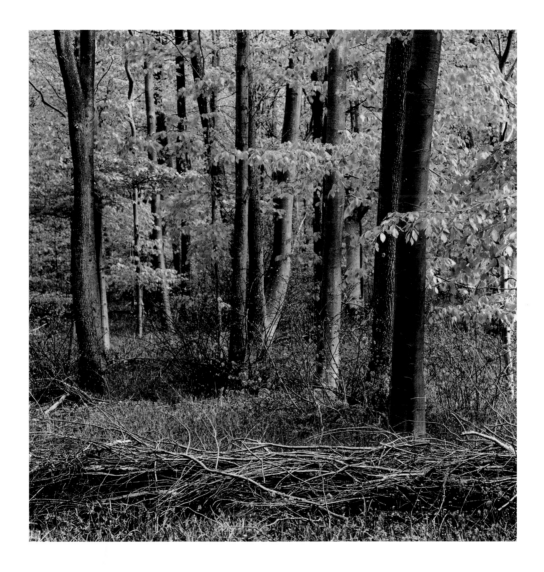

In April and May many Cotswold woods are carpeted with bluebells

Opposite: Sudeley Castle near Winchcombe was once the home of Queen Katherine Parr, the only wife of Henry VIII to survive

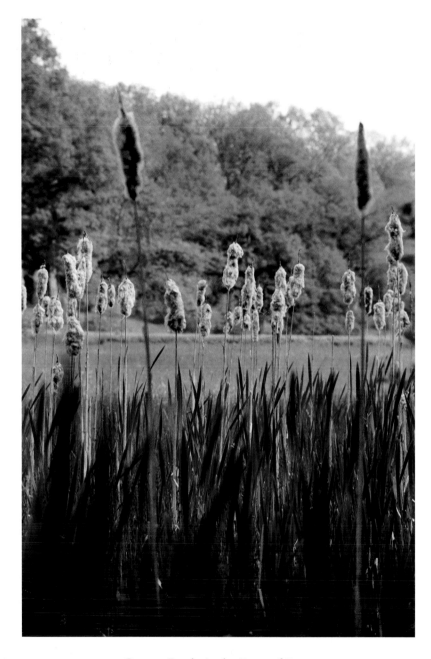

Cannop Ponds, in the Forest of Dean
Opposite: These thatched cottages in Ashton under Hill epitomise the Cotswolds

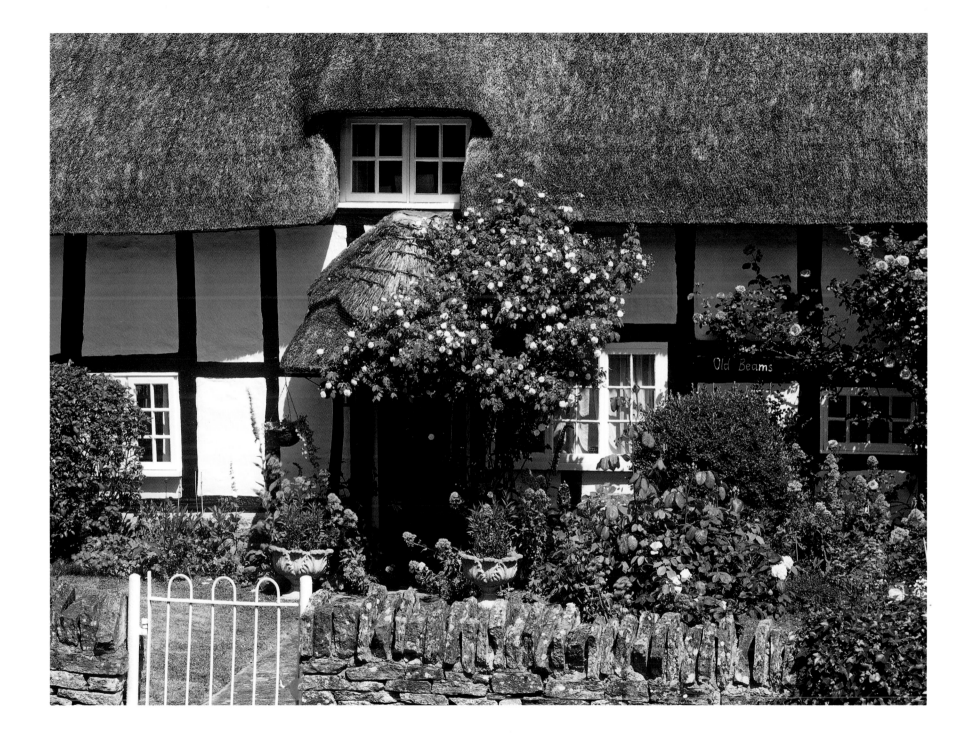

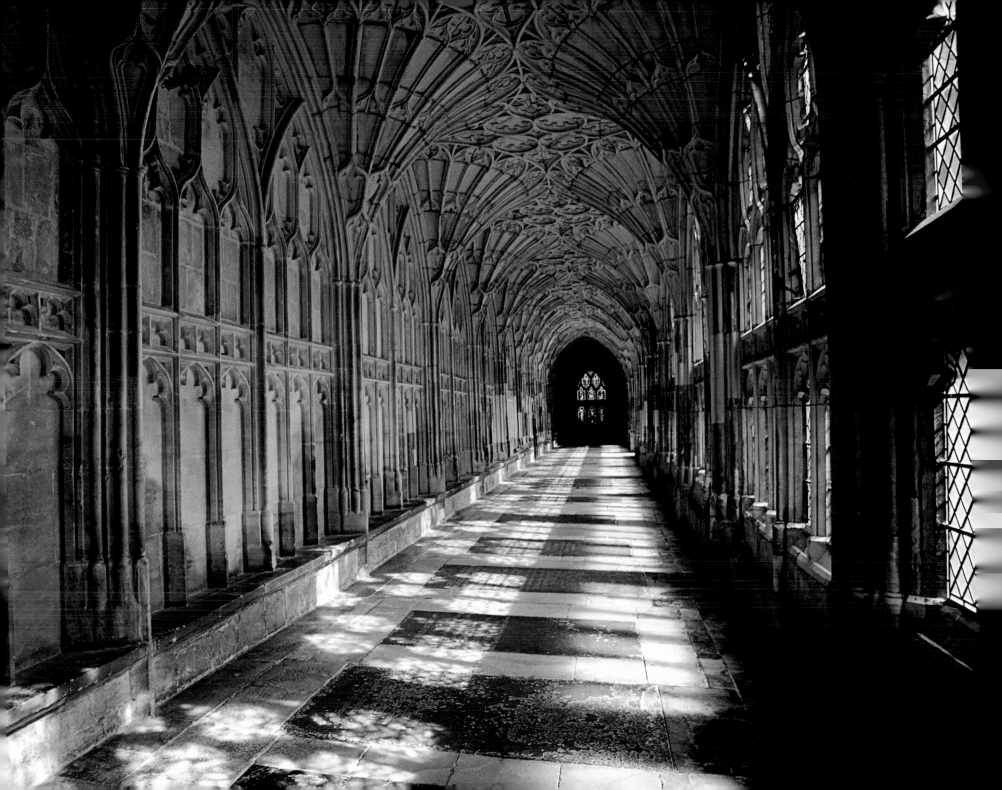

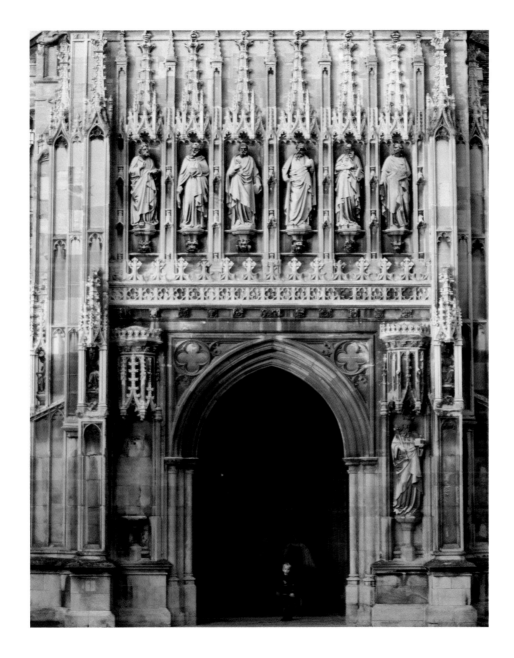

The South Porch of Gloucester Cathedral

Opposite: The fan-vaulted ceilings of Gloucester Cathedral's cloisters date back to the 14th century

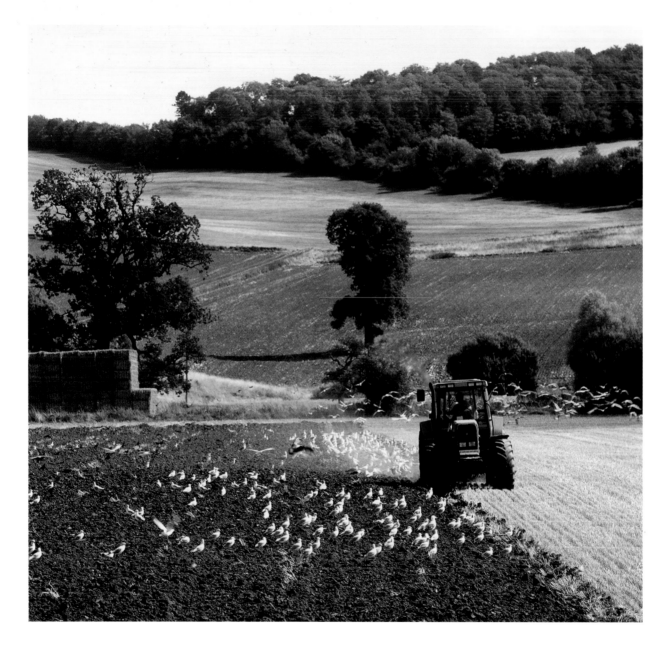

Seagulls follow the plough, near Snowshill
Opposite: The River Colne meanders through grassy meadows near Cassey Compton

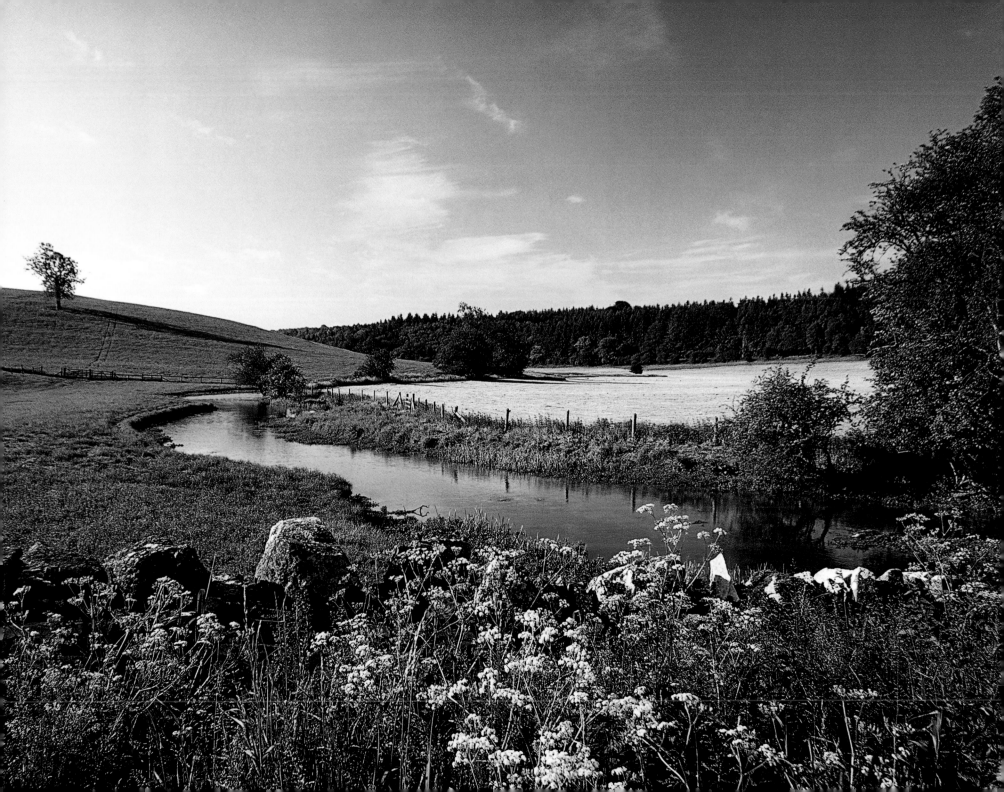

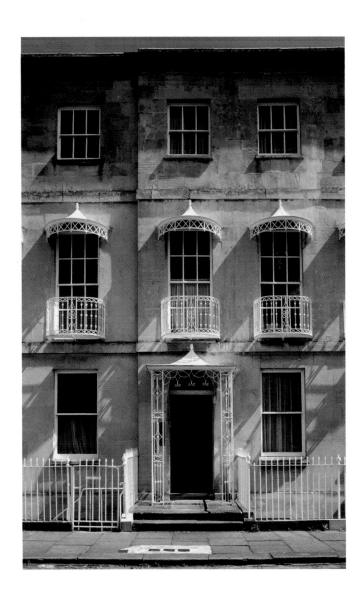

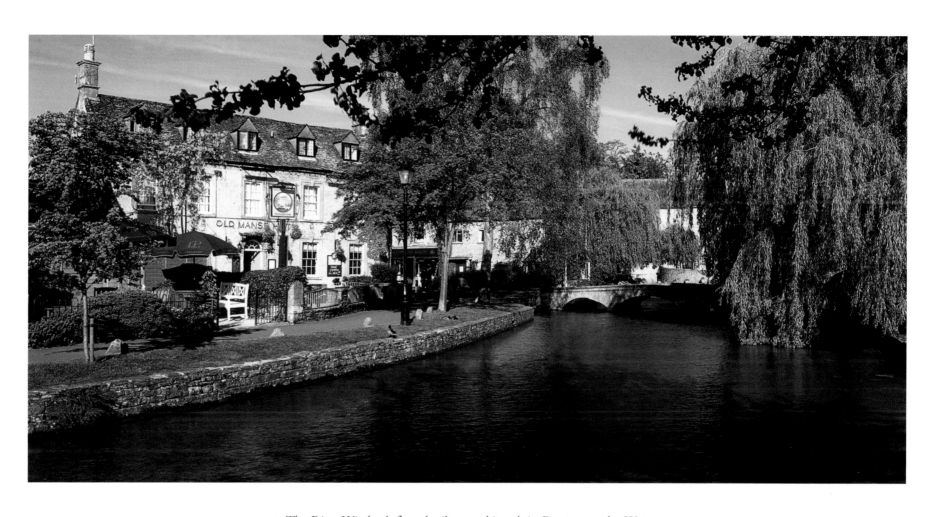

The River Windrush flows lazily past this pub in Bourton-on-the-Water
Opposite: View of terraced houses decorated with white iron work in Cheltenham

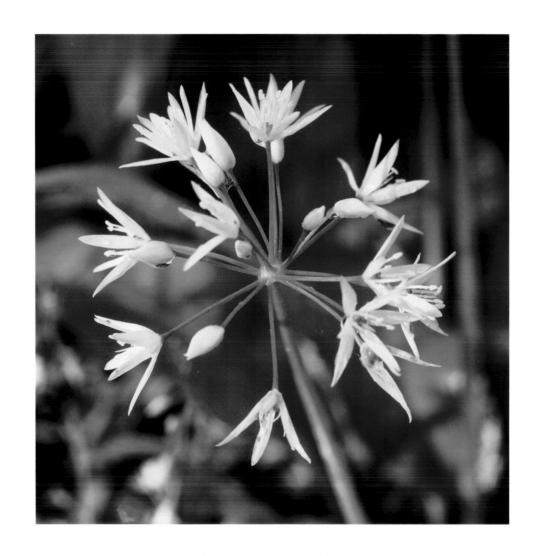

Wild garlic growing near Malmesbury

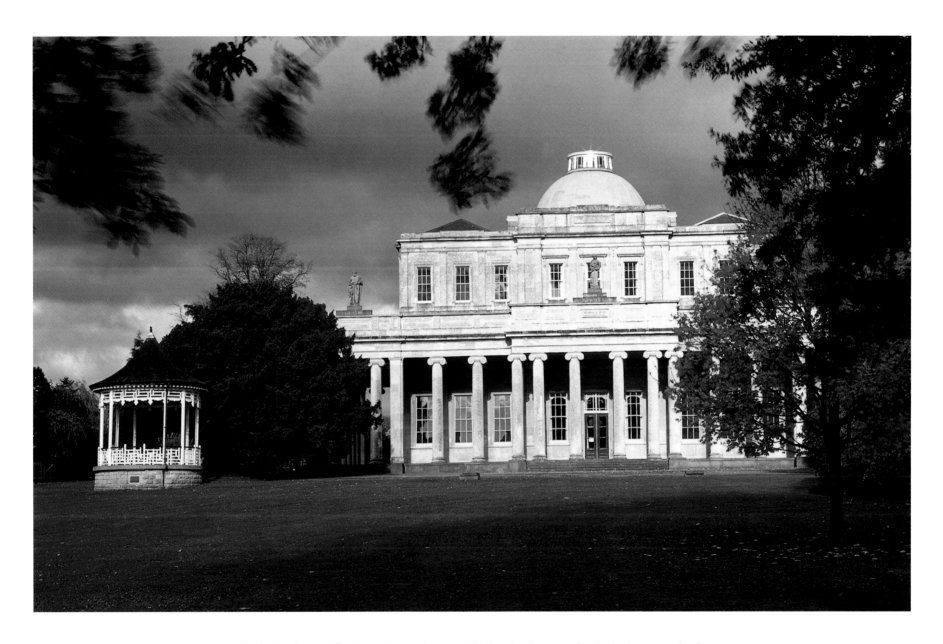

Cheltenham's Pittville Pump Room dates to 1825 and epitomises the Spa's Regency splendour

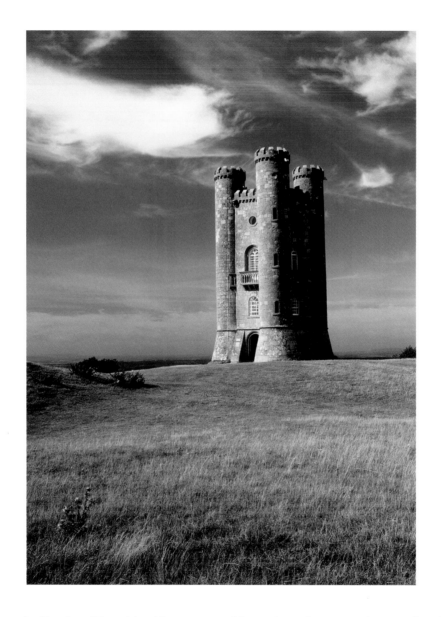

From the Broadway Tower it's said you can see 14 counties and two countries on a clear day
Opposite: Snowshill, where snow settles first in the Cotswolds, though not on a day like this

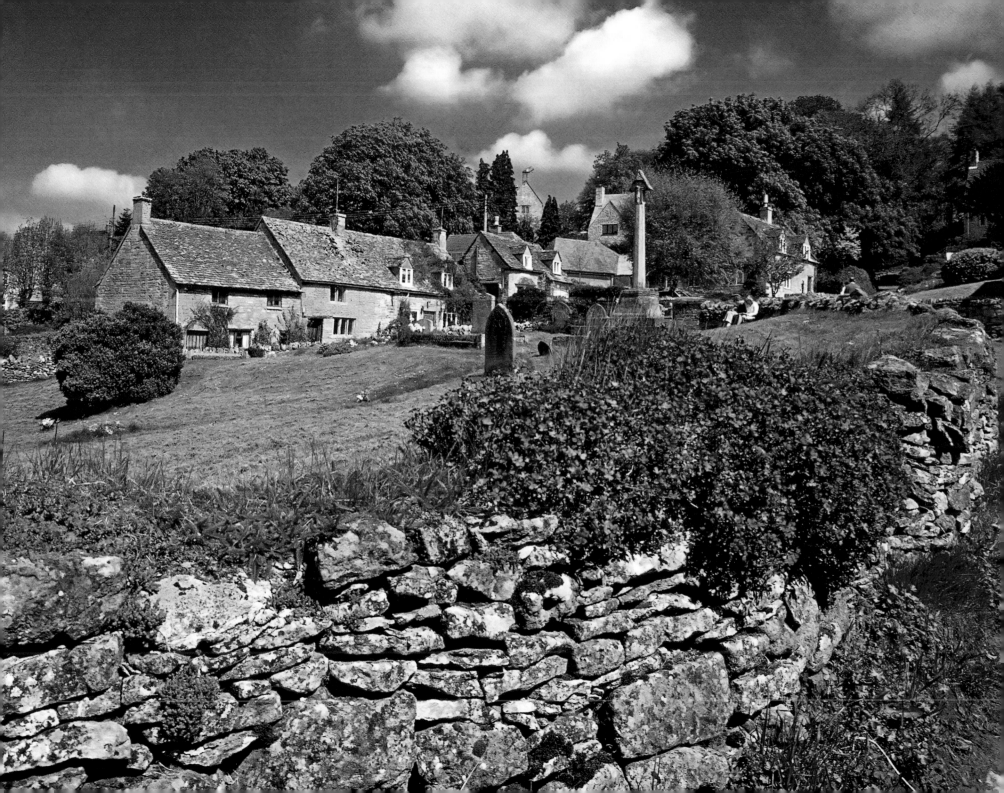

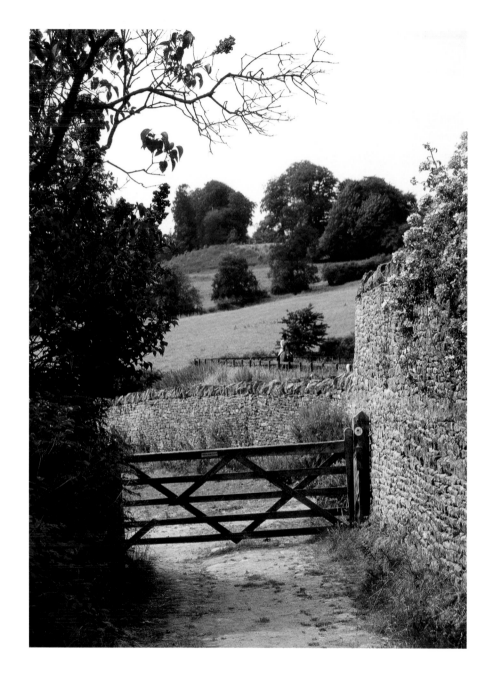

A gate with a Waymark sign, near Bourton-on-the-Hill
Opposite: An almost timeless scene of cattle grazing at ancient Uley Bury

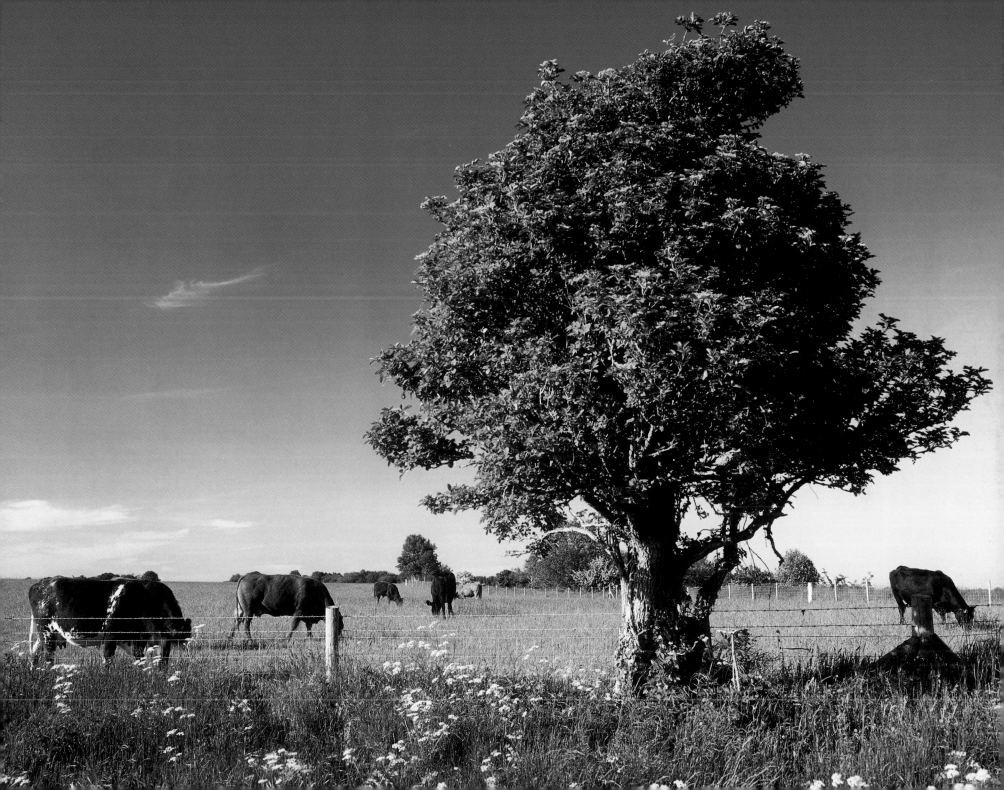

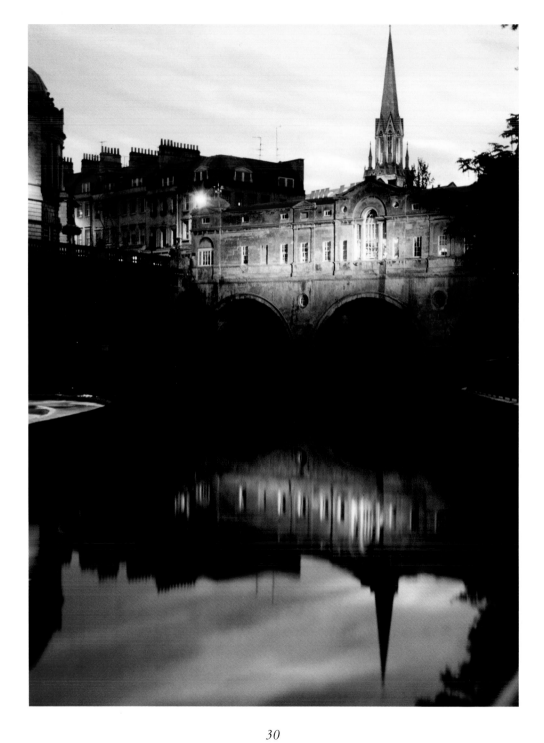

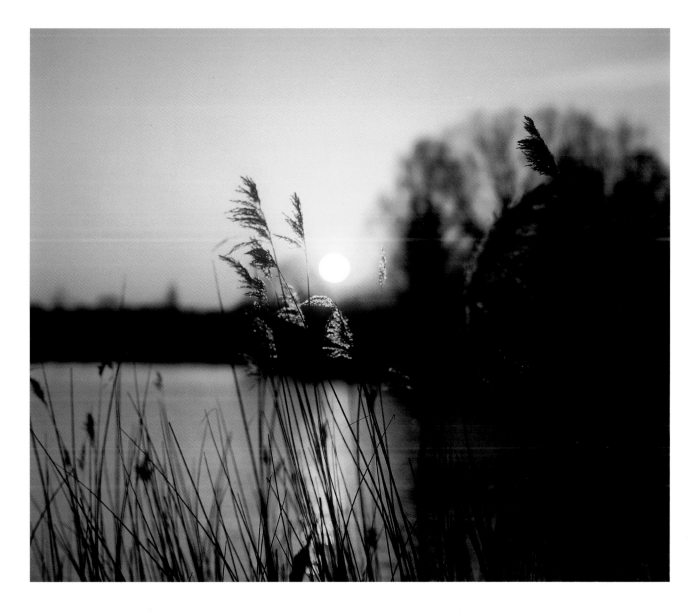

Sunset at the Cotswold Water Park, the largest water park in Britain
Opposite: Bath's Pulteney Bridge has spanned the Avon since it was completed in 1773

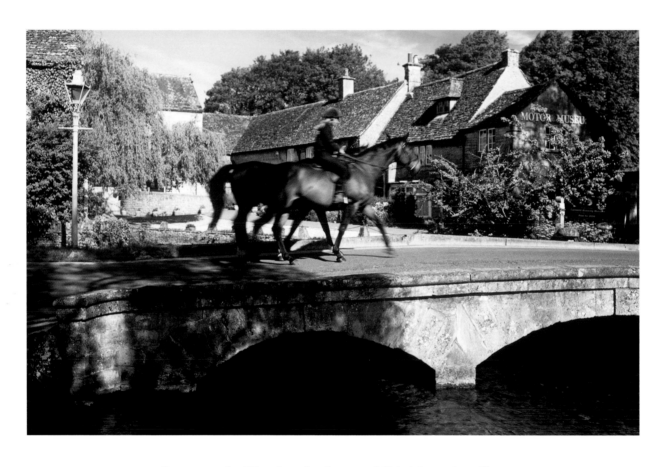

Bourton-on-the-Water has often been voted Britain's prettiest village
Opposite: The Queen Anne-style Dover House can be found in Painswick

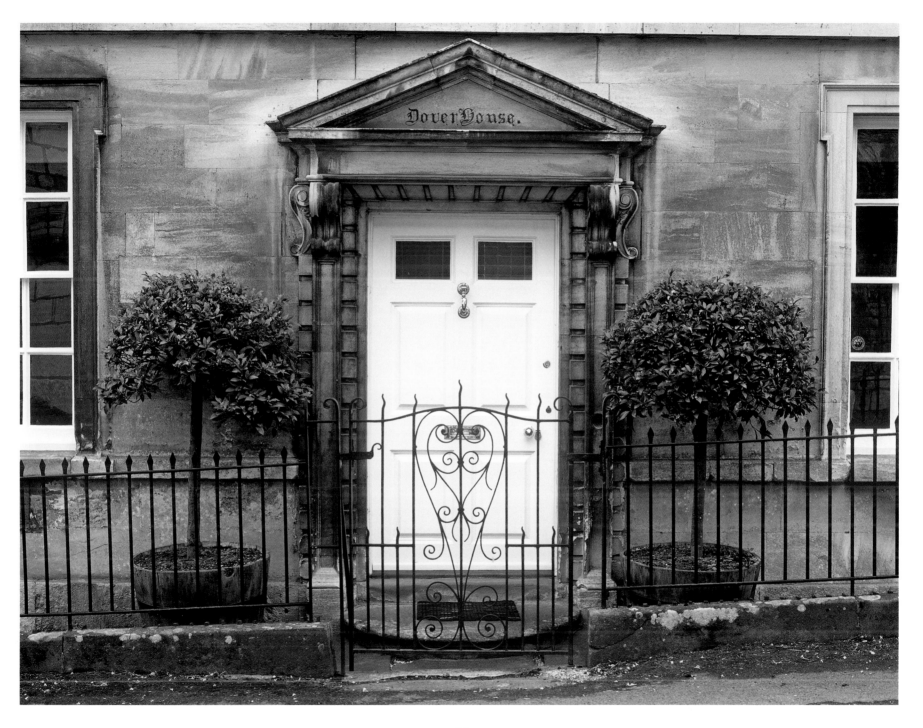

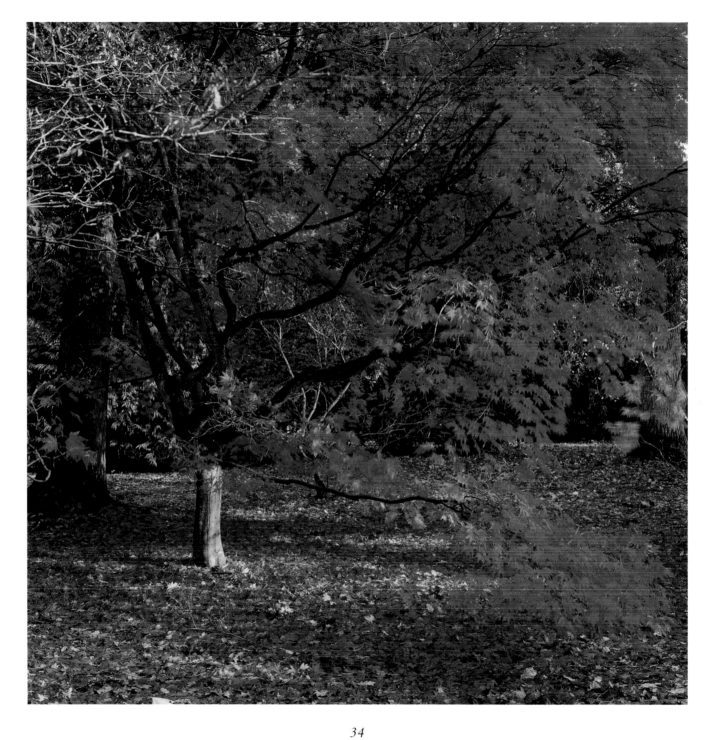

34

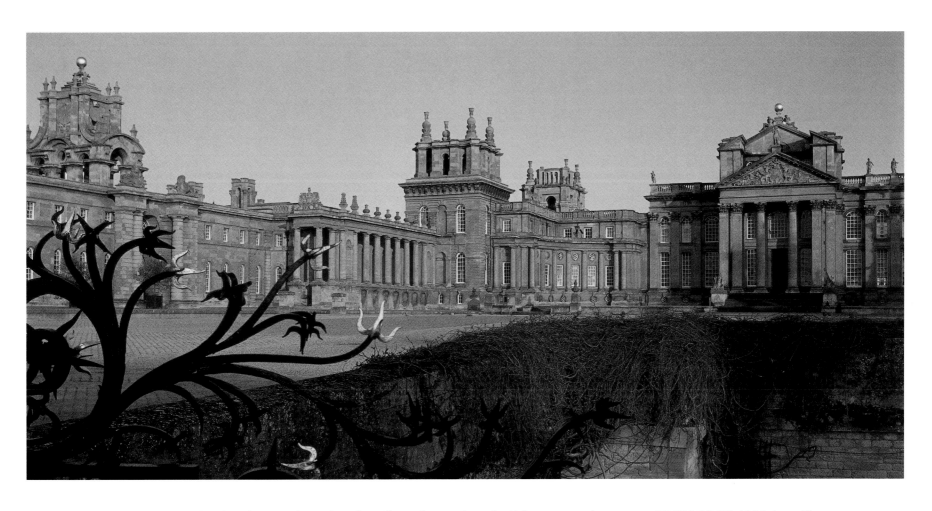

Blenheim Palace has been home to the Dukes of Marlborough since the early 18th century, and it is now a UNESCO World Heritage Site

Opposite: These acers at the National Arboretum in Westonbirt are known for their breathtaking autumnal colour

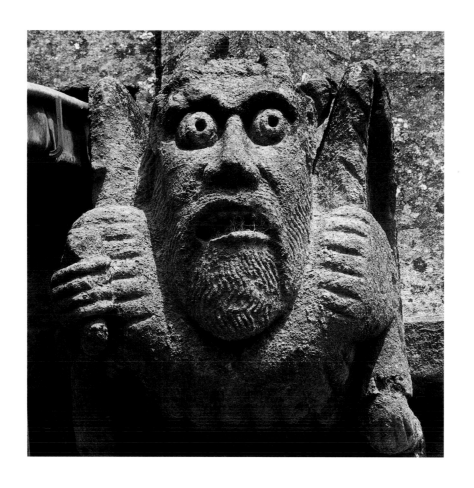

St Peter's Church in Winchcombe is renowned for its marvellous gargoyles
Opposite: This view over Chipping Campden shows how insignificant man still
is in the Cotswold landscape

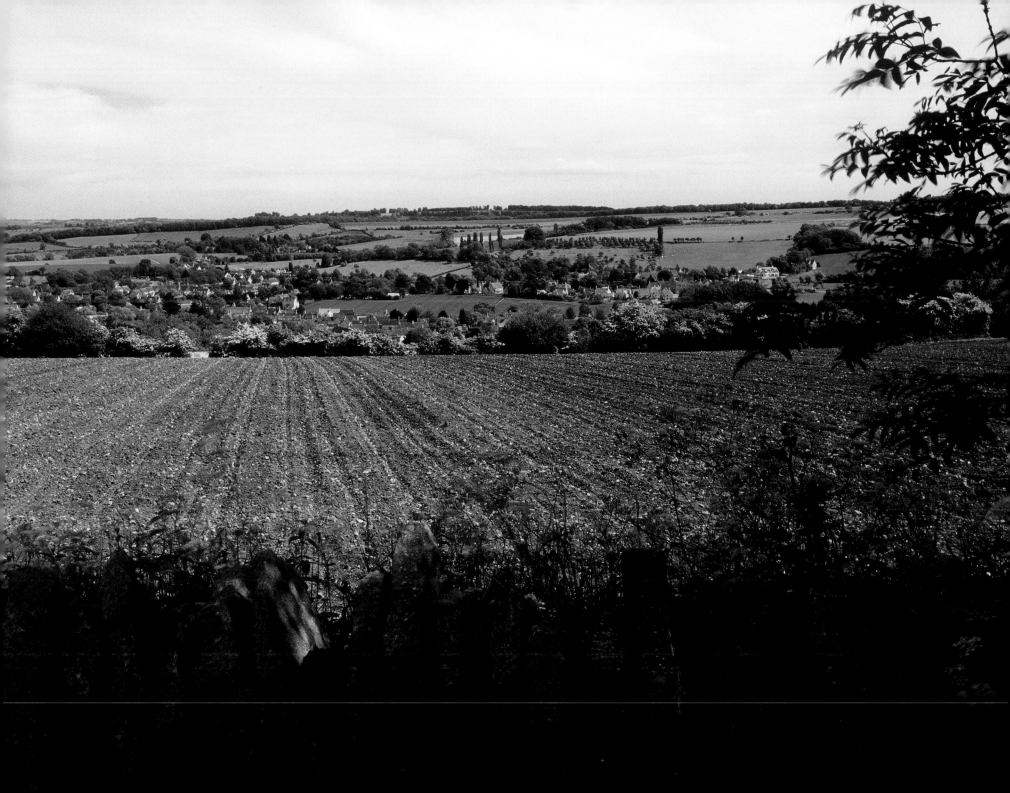

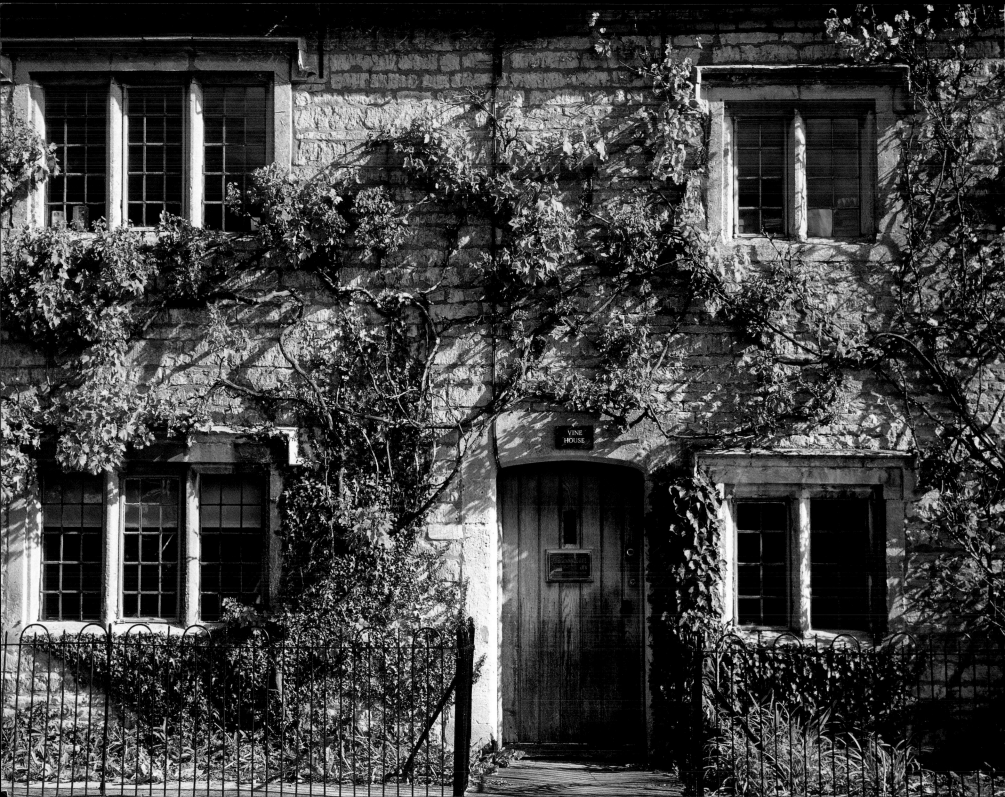

A neatly built wall along Sheep Street in Chipping Campden
Opposite: A vine-covered old house in Bourton-on-the-Water

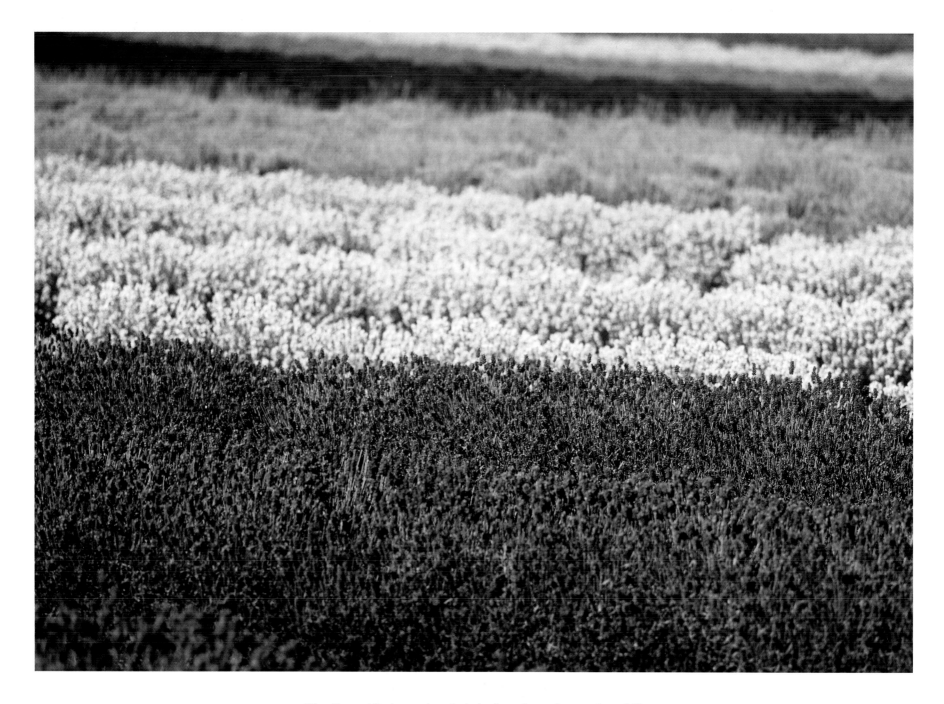

The Cotswold colour palette includes lavender, as here at Snowshill

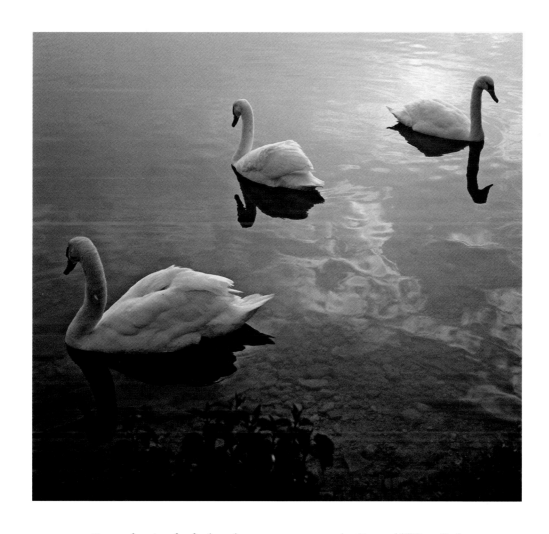

Swans foraging for food as the sun comes up on the Cotswold Water Park

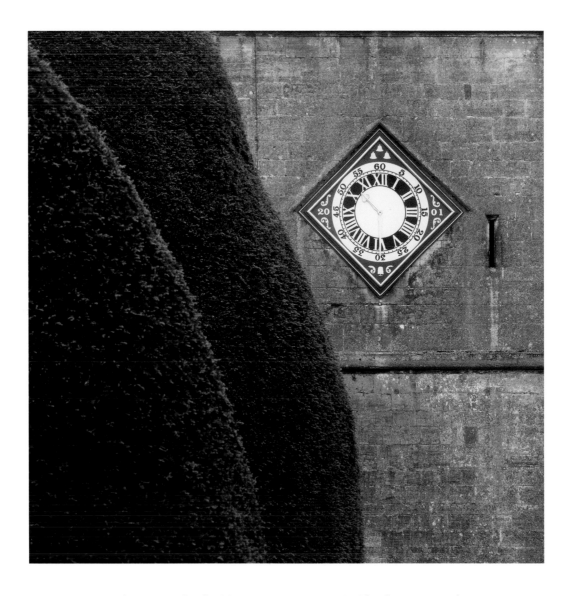

There are said to be 99 yew trees at St Mary's Church in Painswick

Opposite: The River Eye flows through Upper Slaughter then on to meet the waters of the Windrush

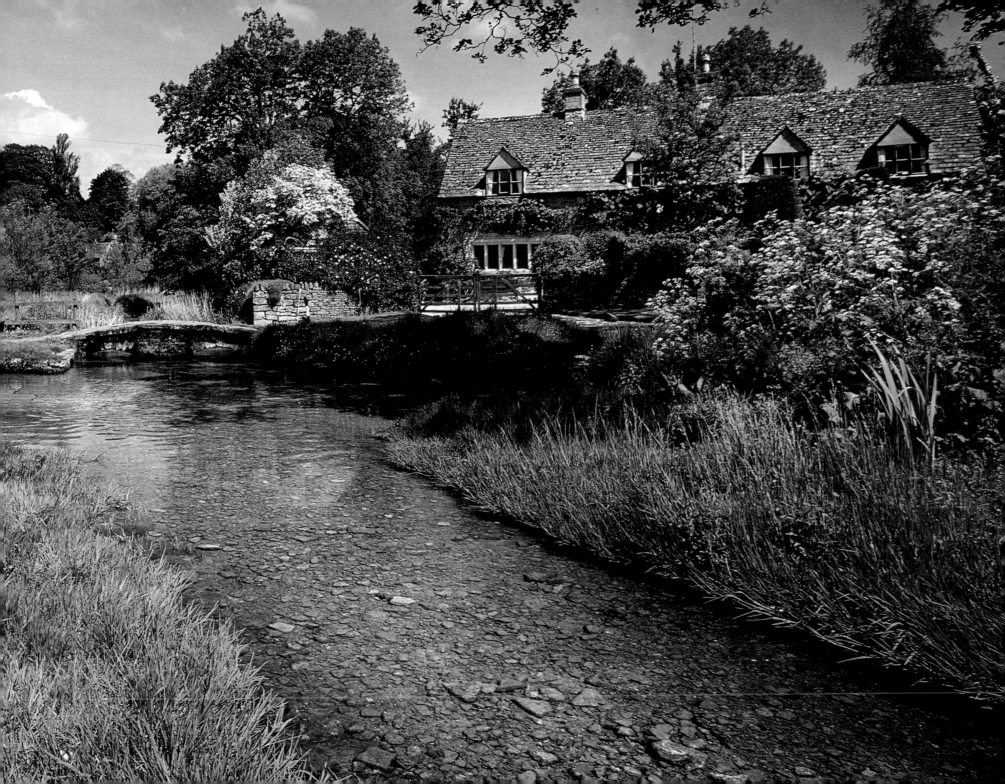

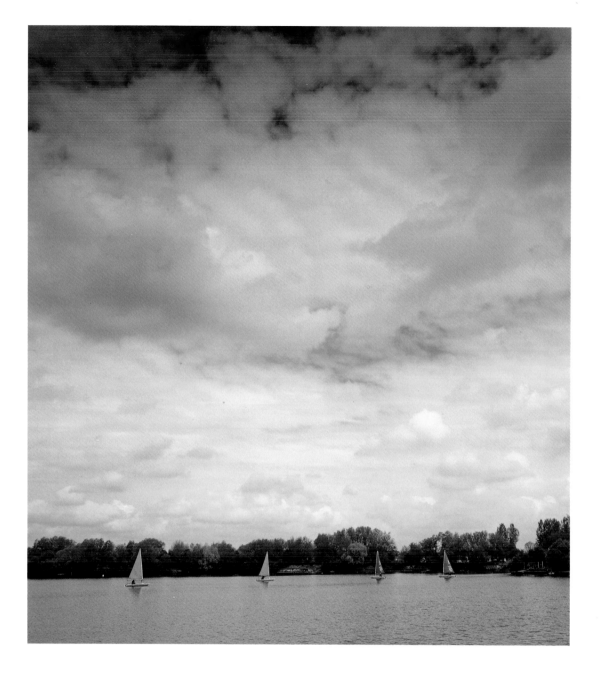

Sailing isn't normally associated with the Cotswolds, but it's popular here at the Cotswold Water Park

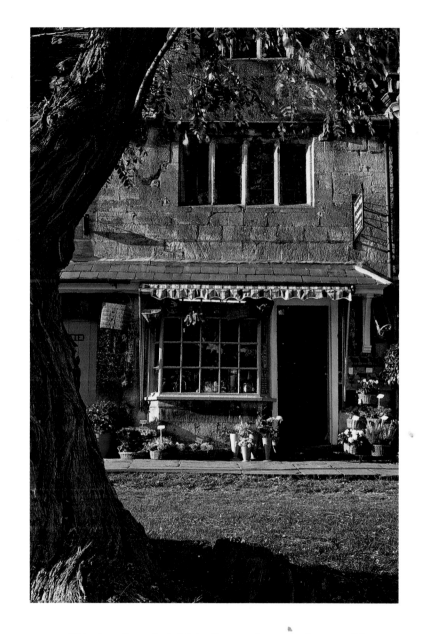

Chipping Campden's Main Street: a long way from city life

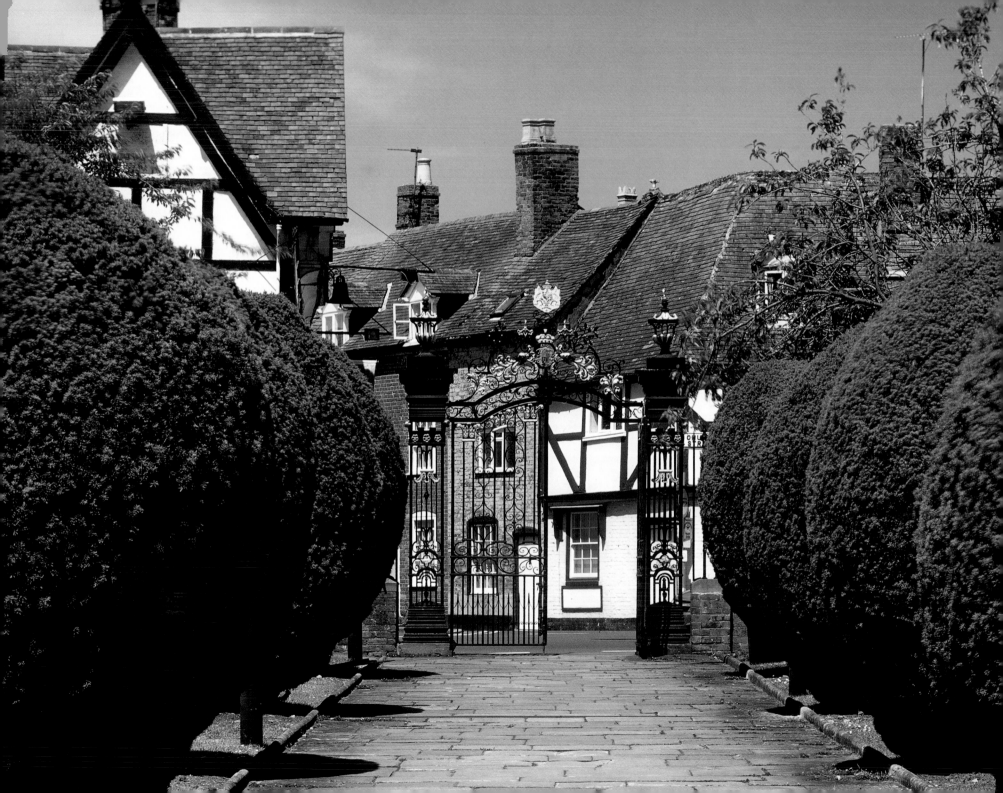

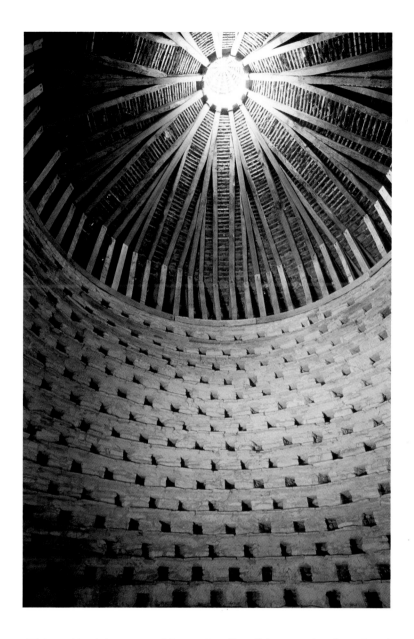

This medieval dovecote at Minster Lovell Hall has a timber-framed roof
Opposite: Many of Tewkesbury's timber-framed buildings date back to
Tudor times, and these on Church Street lead to Tewkesbury Abbey

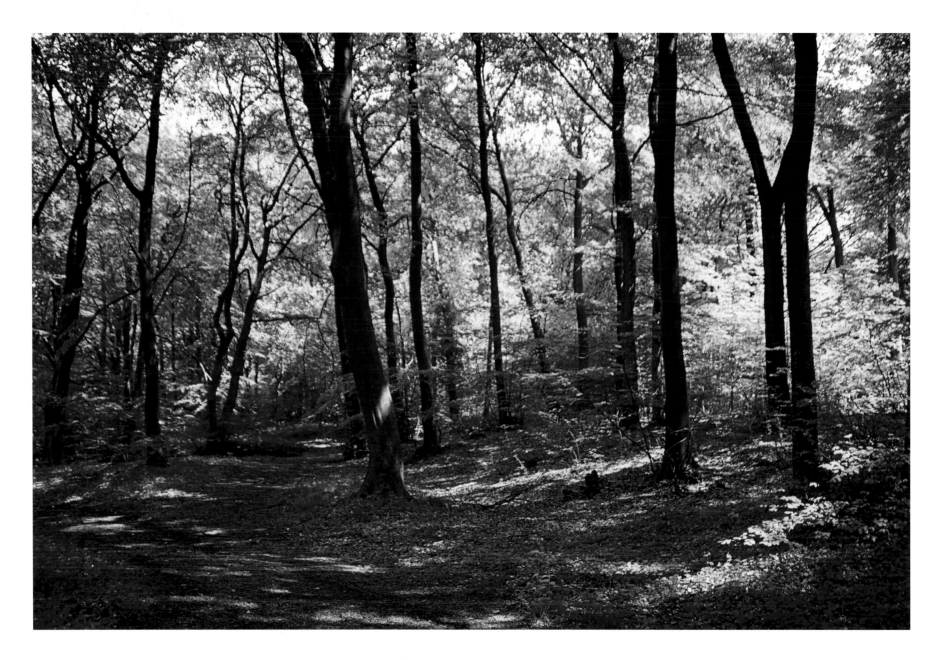

Summer sunshine through the trees at Cranham Woods

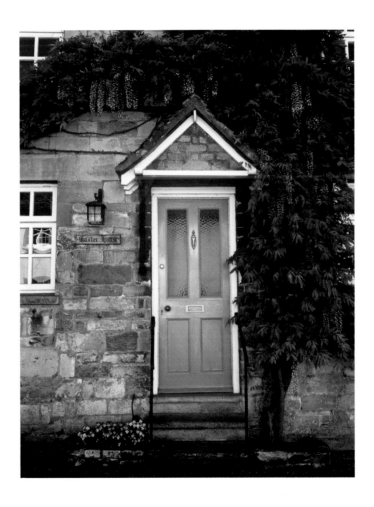

Many of the houses on Hailes Street in Winchcombe are
full of attractive period features

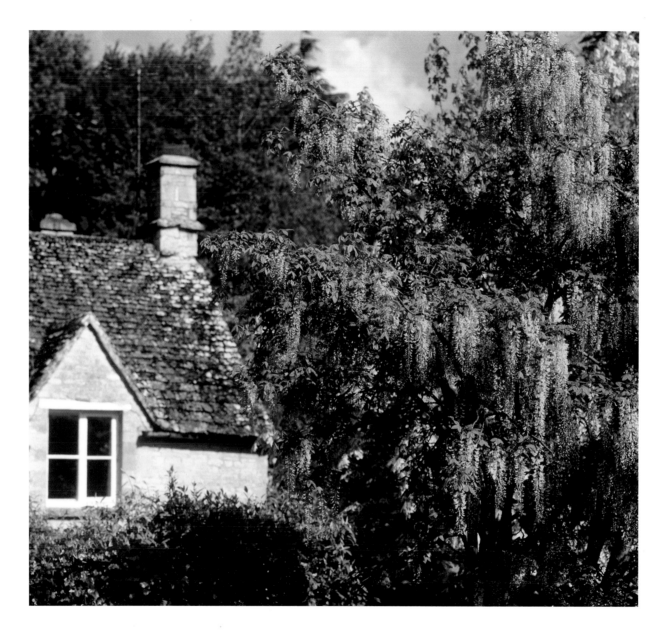

The tiled roof of this cottage in Chedworth shows the passing of the years
Opposite: History, too, shows in this Chedworth stone wall

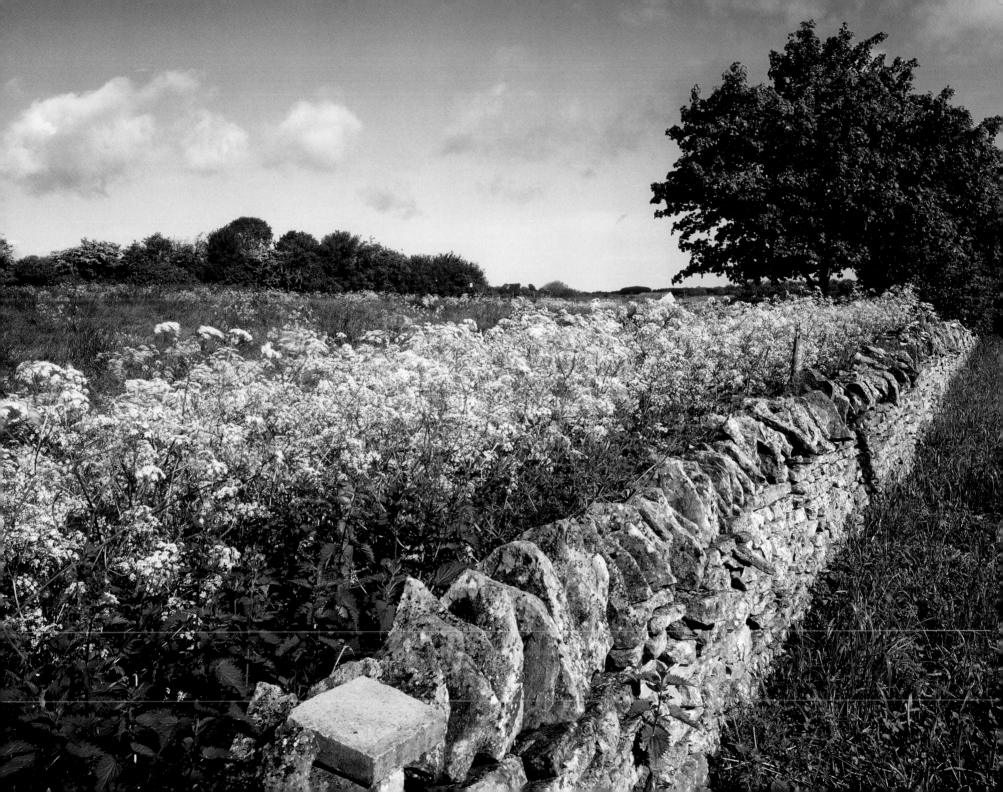

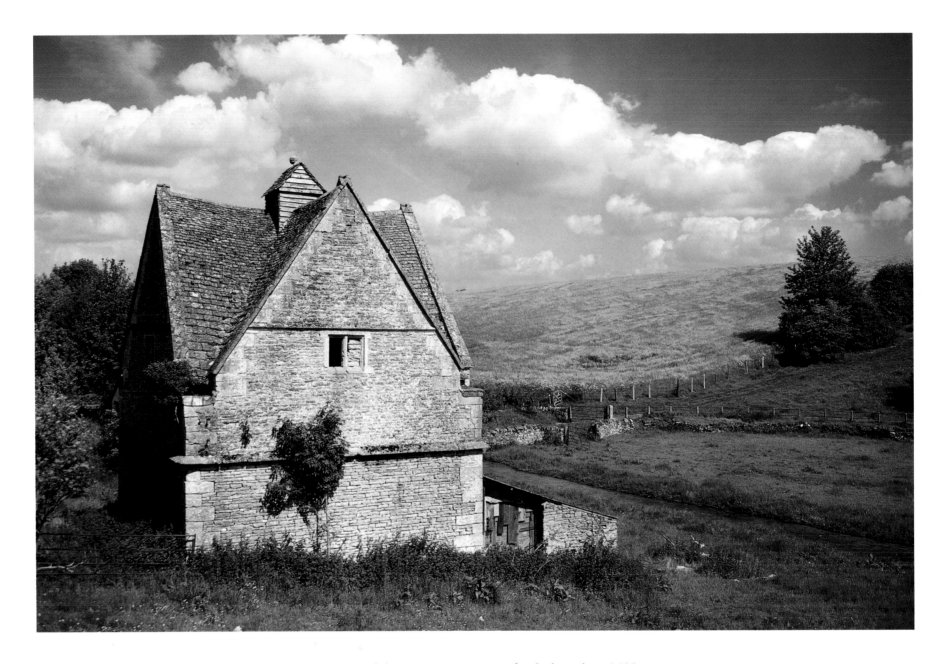

This restored dovecote in Naunton was first built in about 1600
Opposite: Traditional trades survive in the Cotswolds, as here in Stow-on-the-Wold

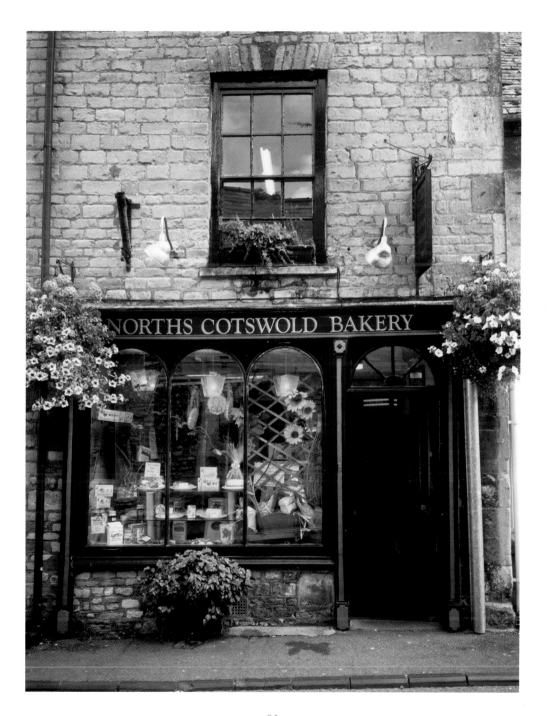

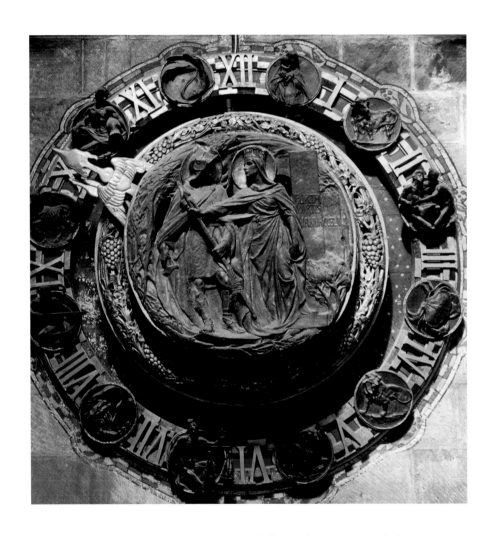

Fascinating detail on a zodiac clock in Gloucester Cathedral
Opposite: Hailes Abbey near Winchcombe was founded in 1246 as a Cistercian monastery,
and its stone cloister arches are as dramatic now as they ever were

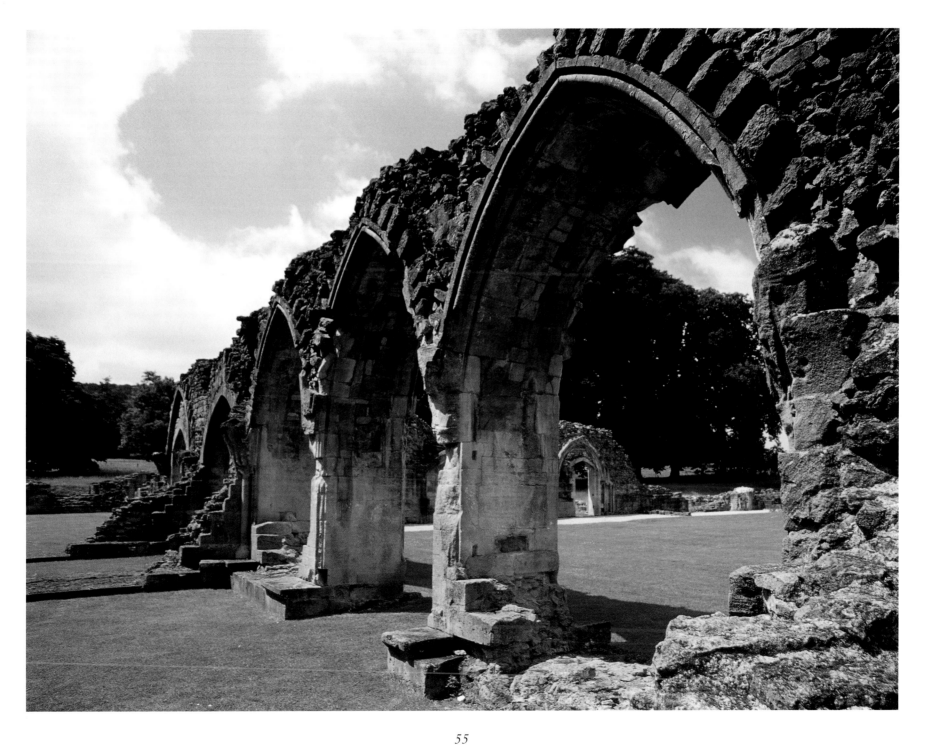

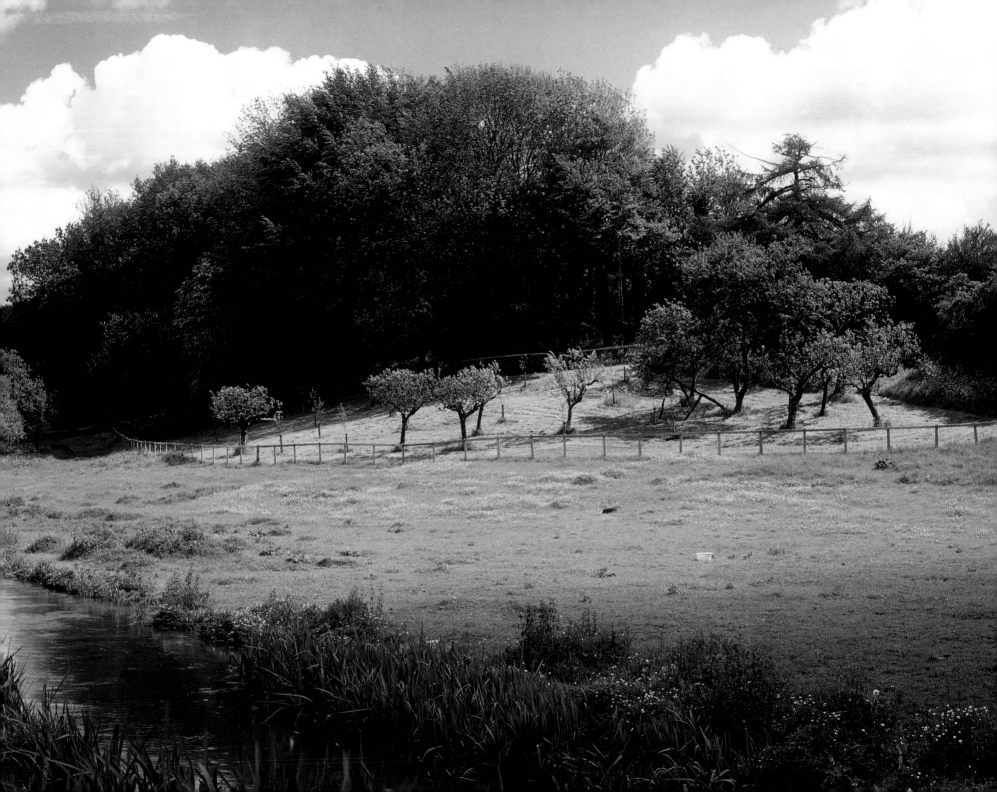

The gate to the churchyard of St Andrew's in Chedworth
Opposite: The River Coln is rich in freshwater fish

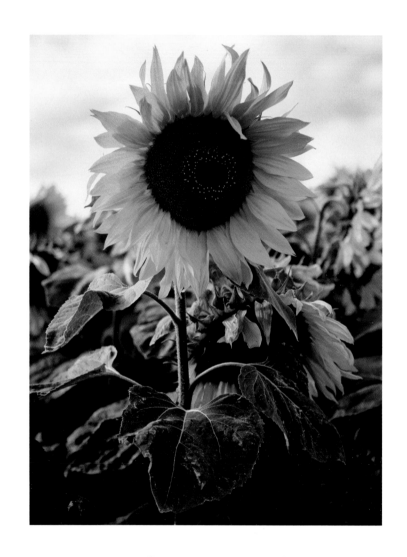

Sunflowers growing at Snowshill

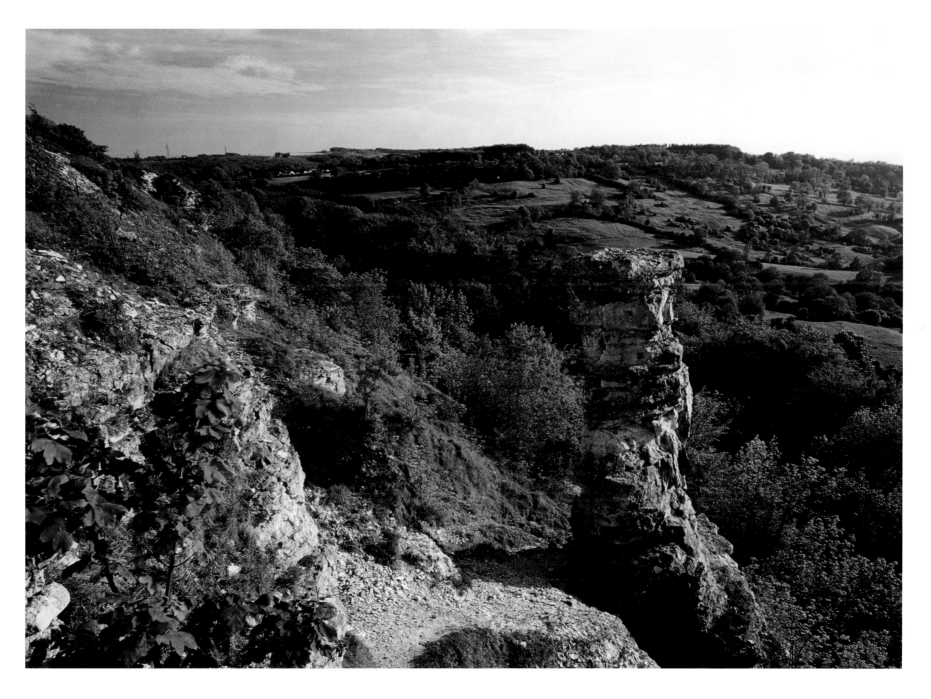

The origins of the Devil's Chimney on Leckhampton Hill have never been explained. Does the devil live below?

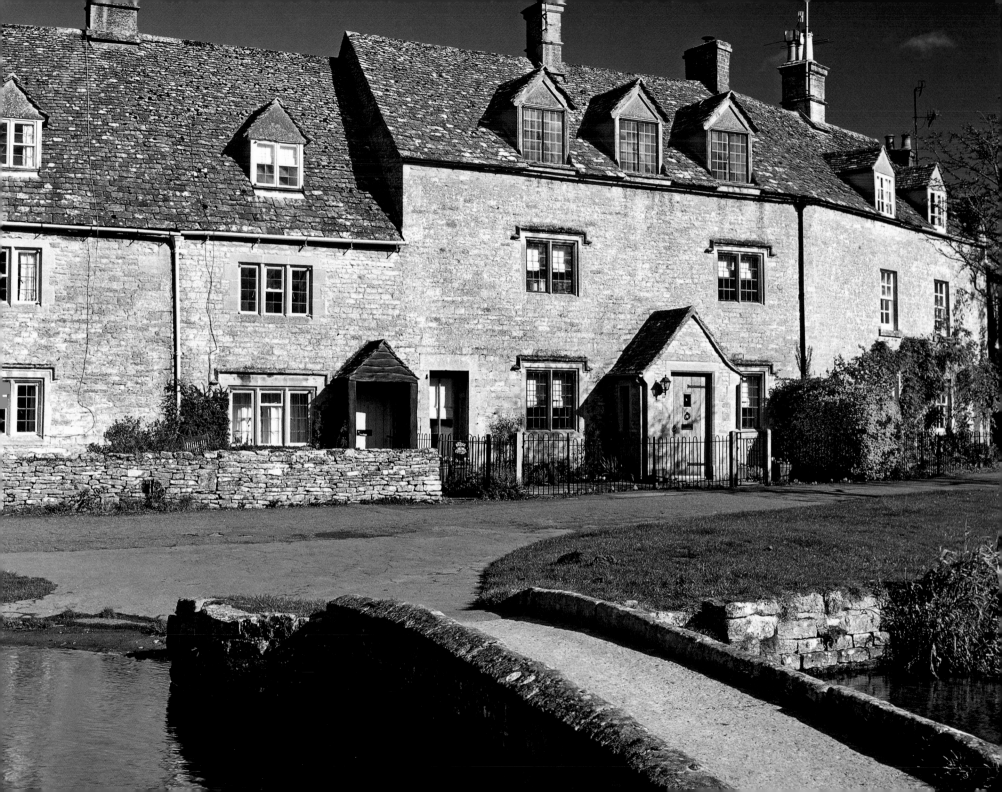

Flowers claim their patch of wall in the tiny hamlet of Ablington
Opposite: One of two small bridges that cross the stream in Lower Slaughter

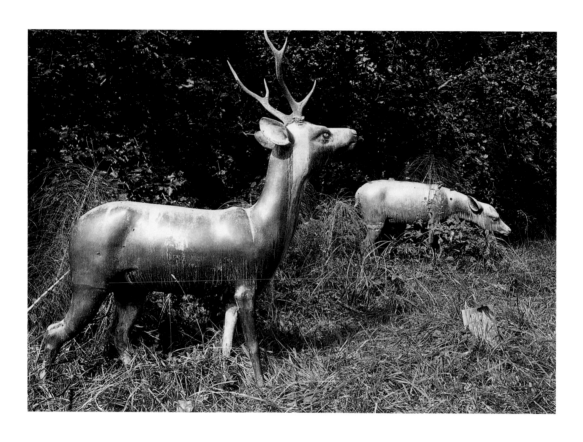

Animal sculptures in the undergrowth at Batsford Arboretum
Opposite: Bredon Hill shows the Vale of Evesham in all its glory

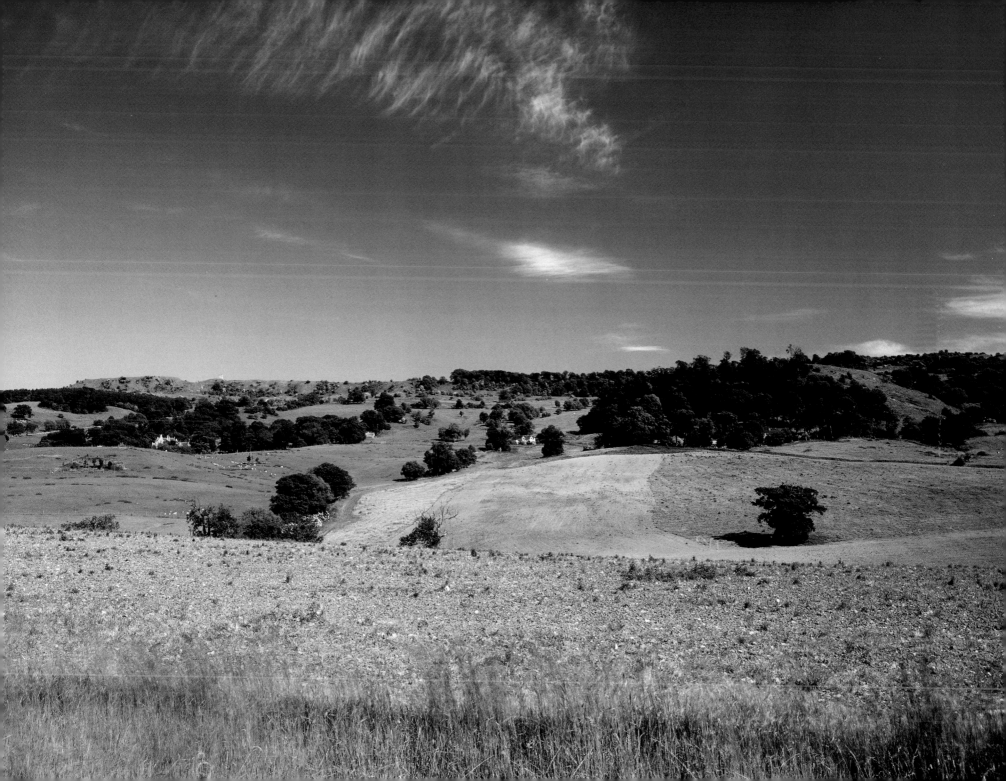

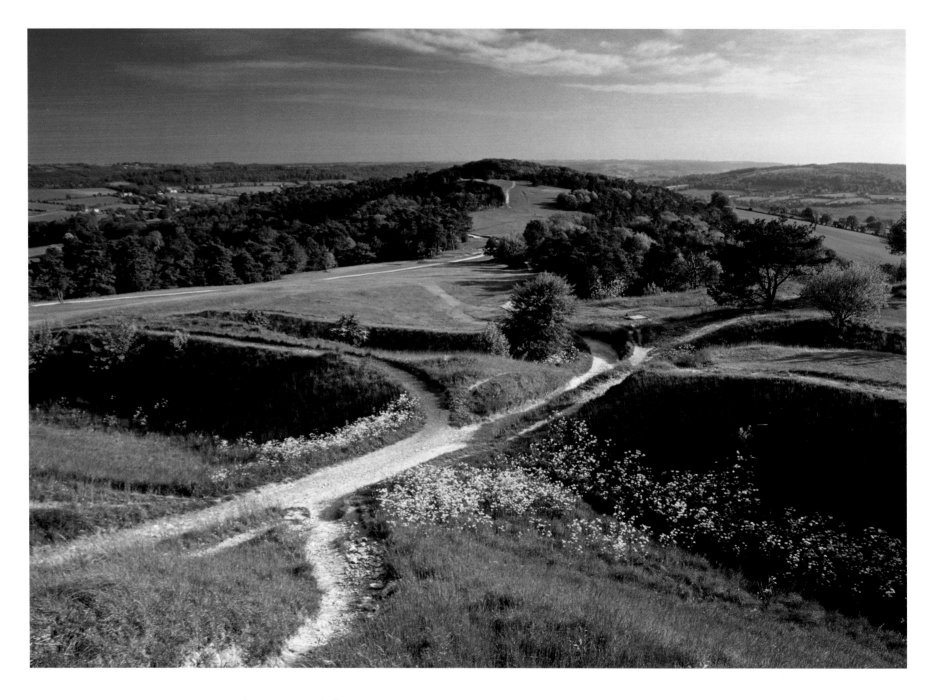

Painswick Beacon spreads for 250 acres, and the 102-mile Cotswold Way long distance trail passes through

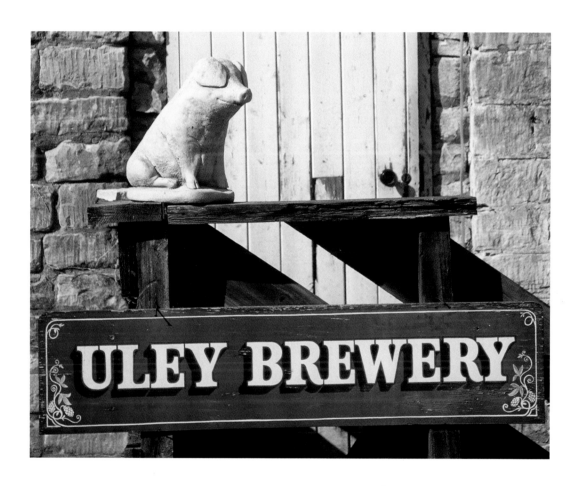

Uley Brewery dates back to 1833 when it was first built on the site of one of Uley's natural springs.
It was revived in 1985 and Gloucester pigs are a recurring theme. Anyone for a pint of Pig's Ear?

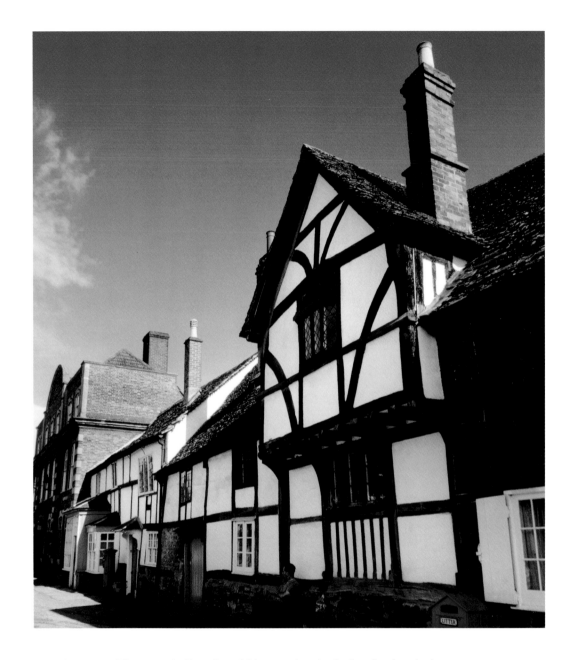

This scene in Lacock could be any time in the last few hundred years
Opposite: Gloucester Docks lie conveniently between the sea port of Bristol and the industrial city of Birmingham

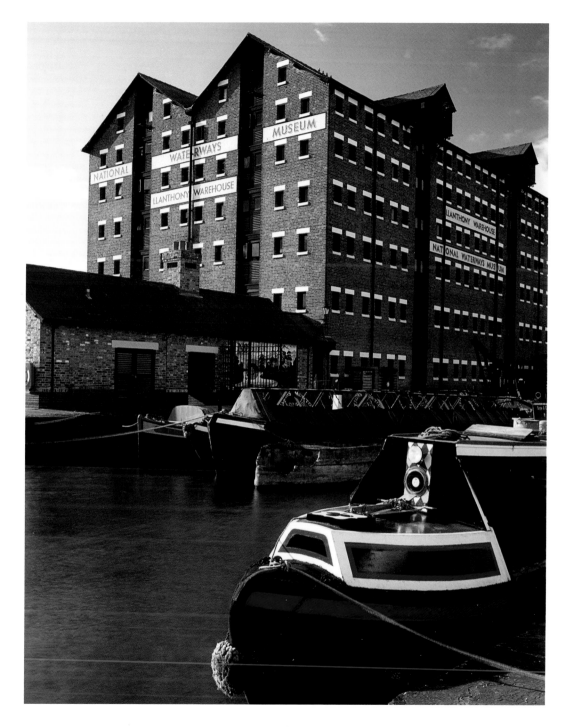

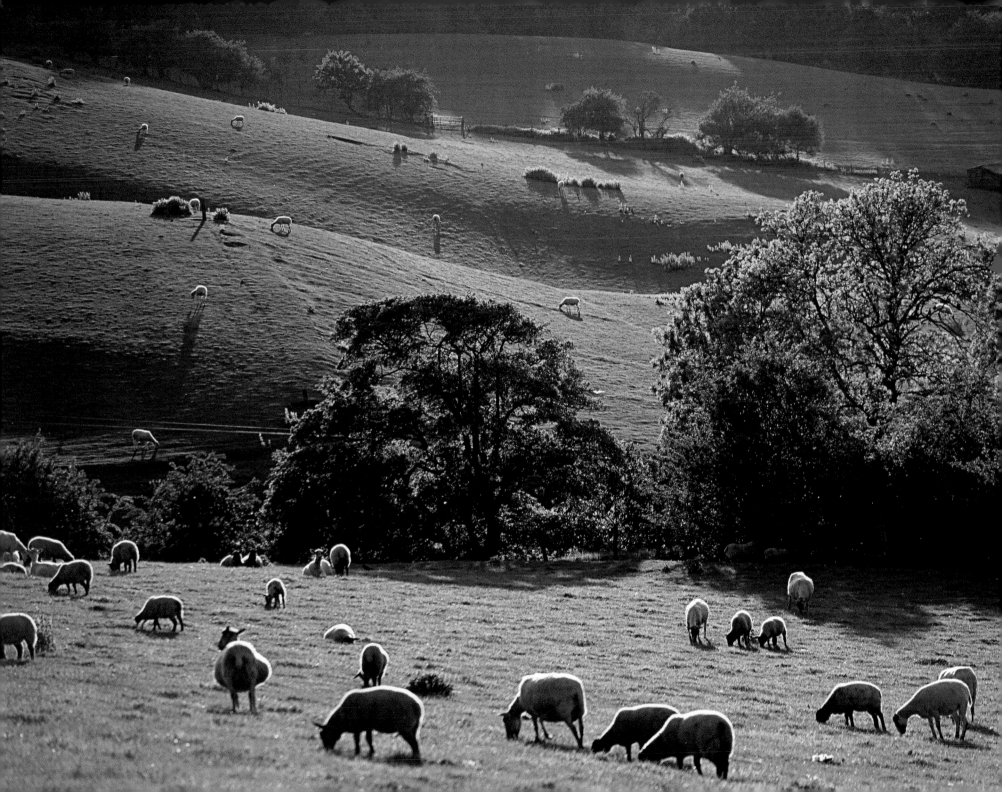

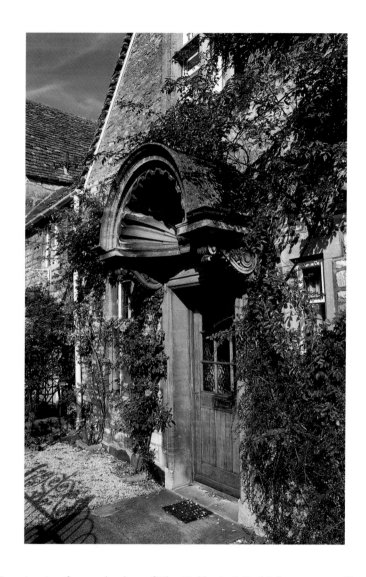

*Creeping ivy frames the door of The Gables in Minchinhampton, a village
which stands remote and high on the Cotswold Edge
Opposite: Sheep have always grazed the hills around Snowshill*

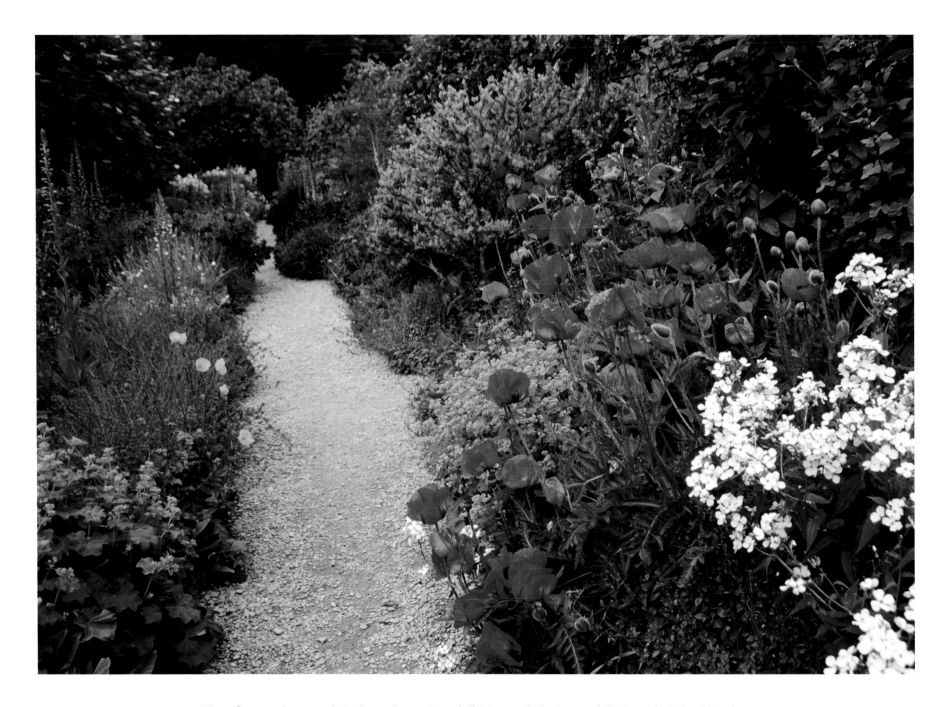

These flowers colour a path in the garden at Snowshill Manor, which sits on a hill above the Vale of Evesham

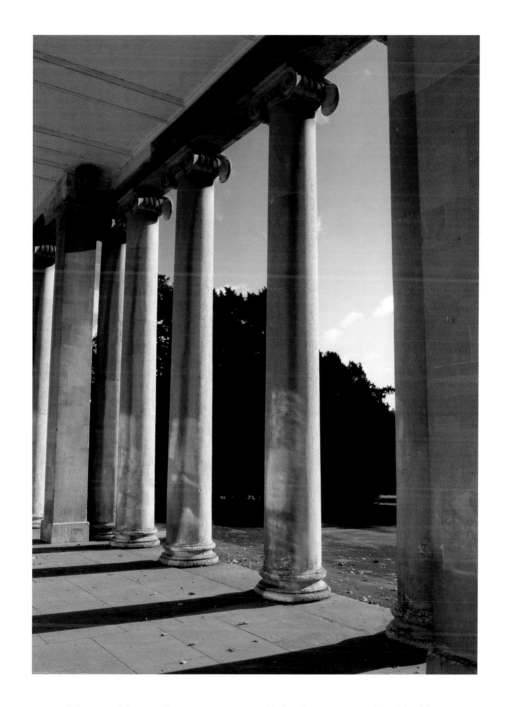

The graceful Pittville Pump Room in Cheltenham is now a listed building

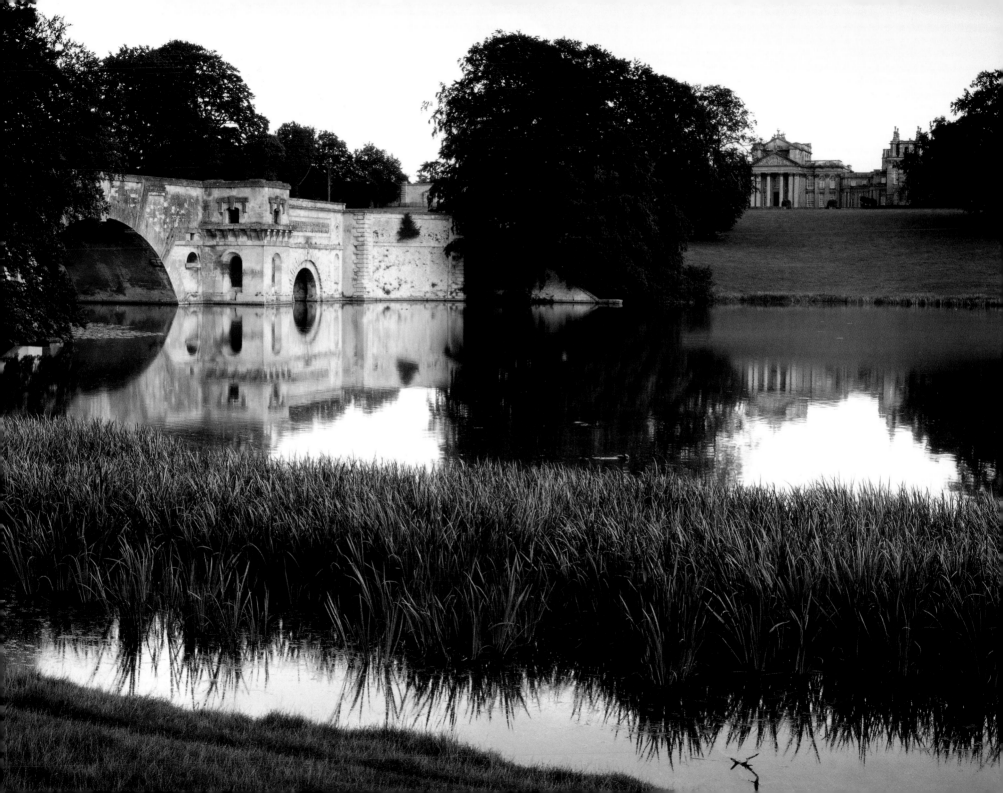

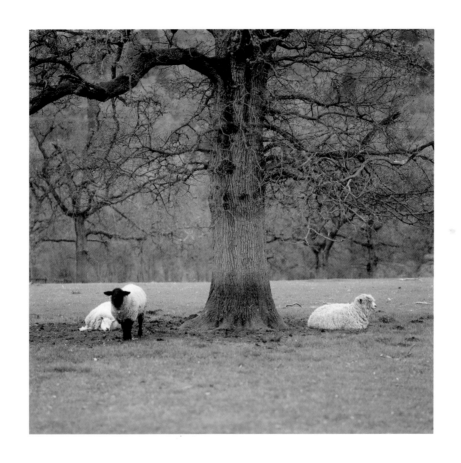

Contented sheep, near the village of Chedworth
Opposite: Blenheim Palace, birthplace of Sir Winston Churchill

*The 16th-century Egypt Mill near Nailsworth, which once took its waters
from the River Frome, is now a smart hotel*

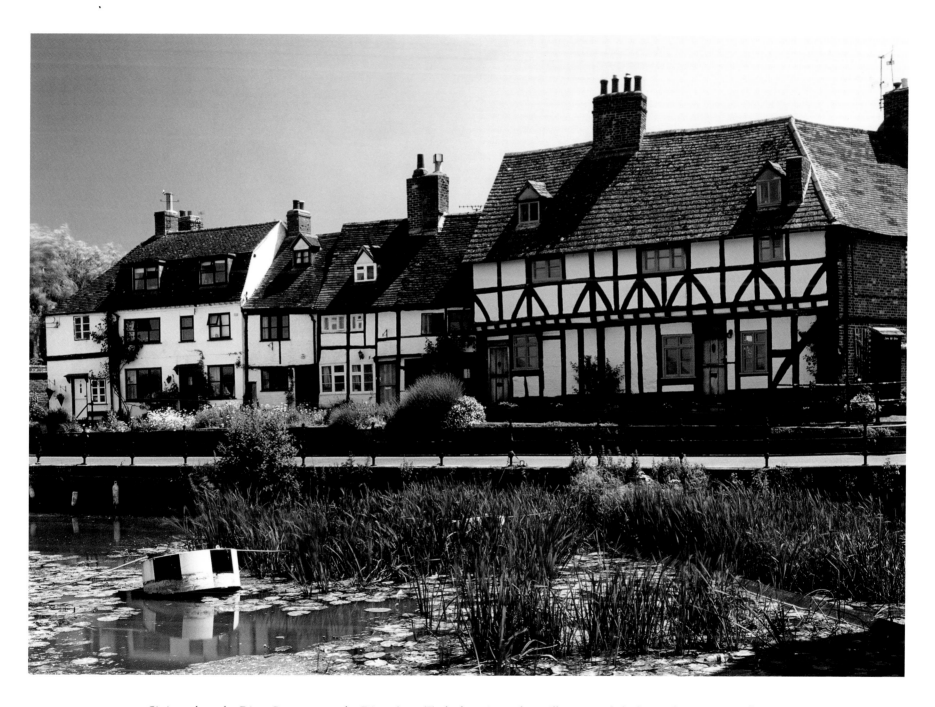

Sitting where the River Severn meets the River Avon, Tewkesbury is another mill town, and the houses here are on Mill Street

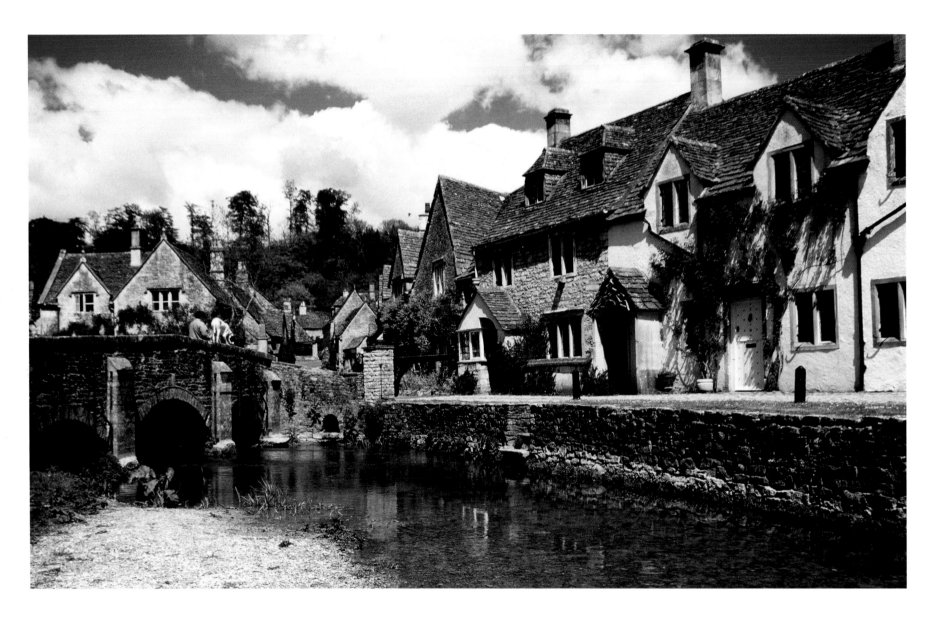

Castle Combe is another Cotswold village that has been called 'the prettiest village in England', and here the medieval Town Bridge is seen crossing over the village's By Brook
Opposite: A field of blue flax paints a hillside near Broadway

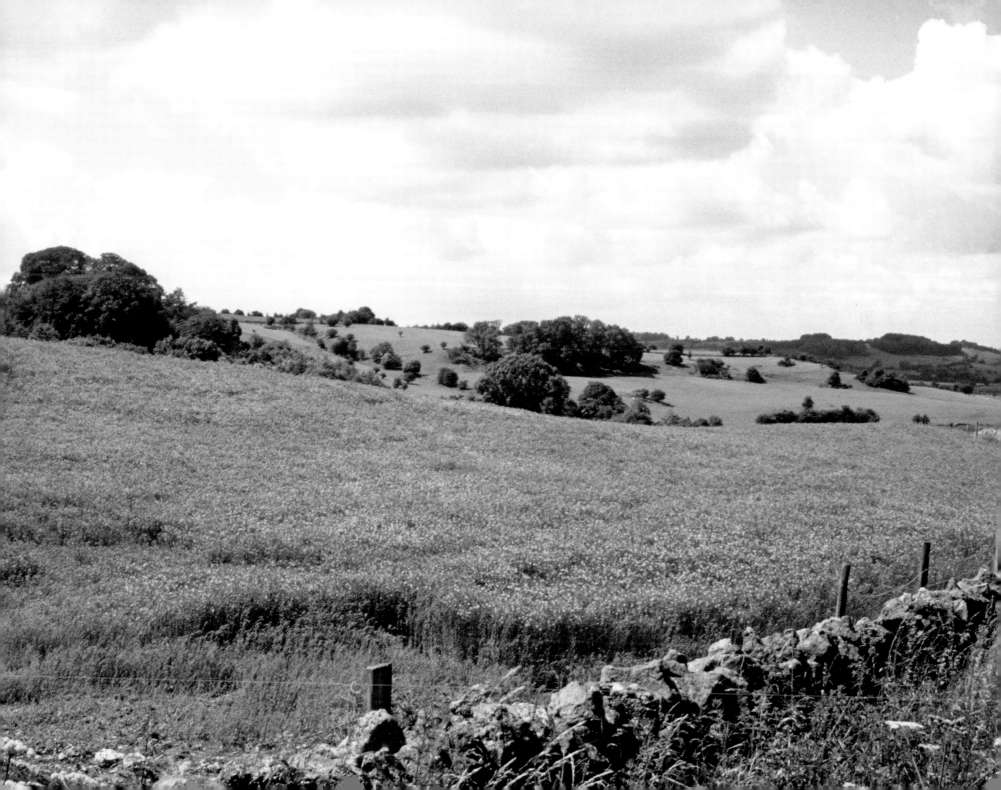

This magnificent oak is just one of over 3000 different trees and shrubs at the National Arboretum at Westonbirt
Opposite: A stone wall near Chedworth is man's mark on the landscape

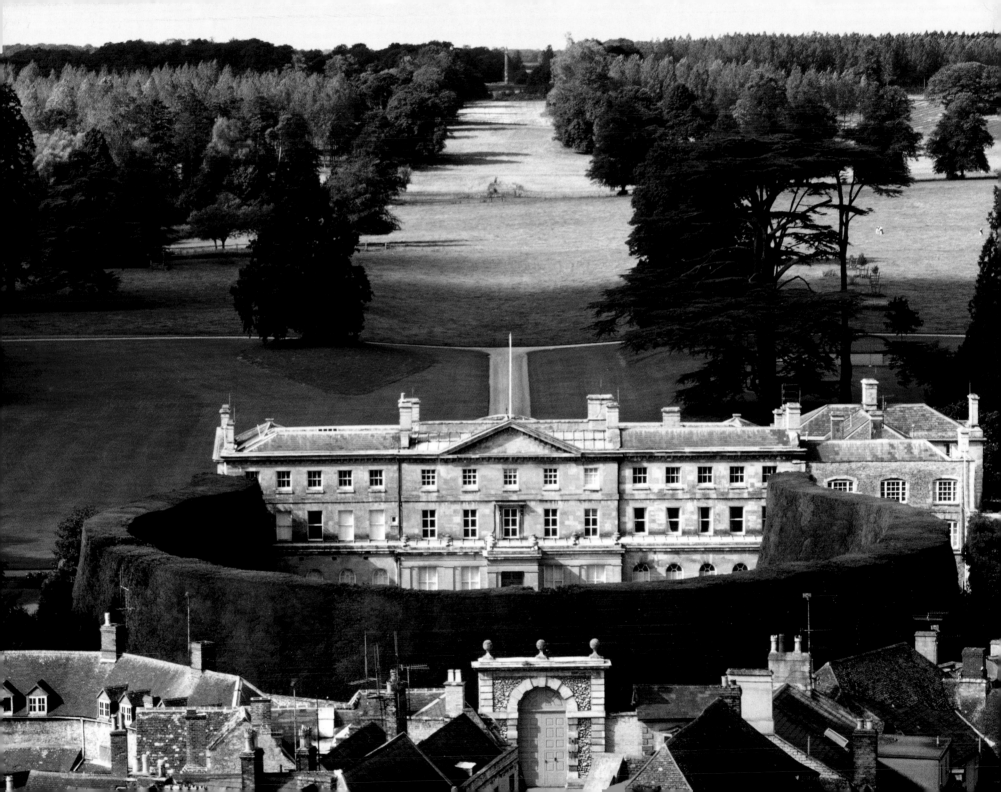

The beauty of sun on wood and Cotswold stone in Winchcombe
Opposite: Alexander Pope and Jonathan Swift have been among the
distinguished visitors to the 18th-century Cirencester House, hidden
from the town by an unusual and splendid yew hedge

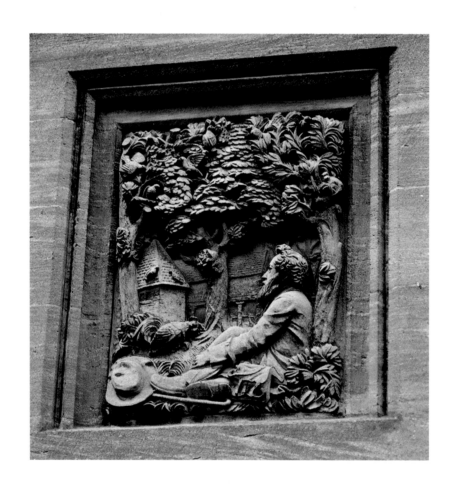

This intricate stone carving adorns one of the William Morris Memorial Cottages in Kelmscott and depicts William Morris himself, founder of the Arts and Crafts movement, in thoughtful enjoyment of the Cotswold countryside

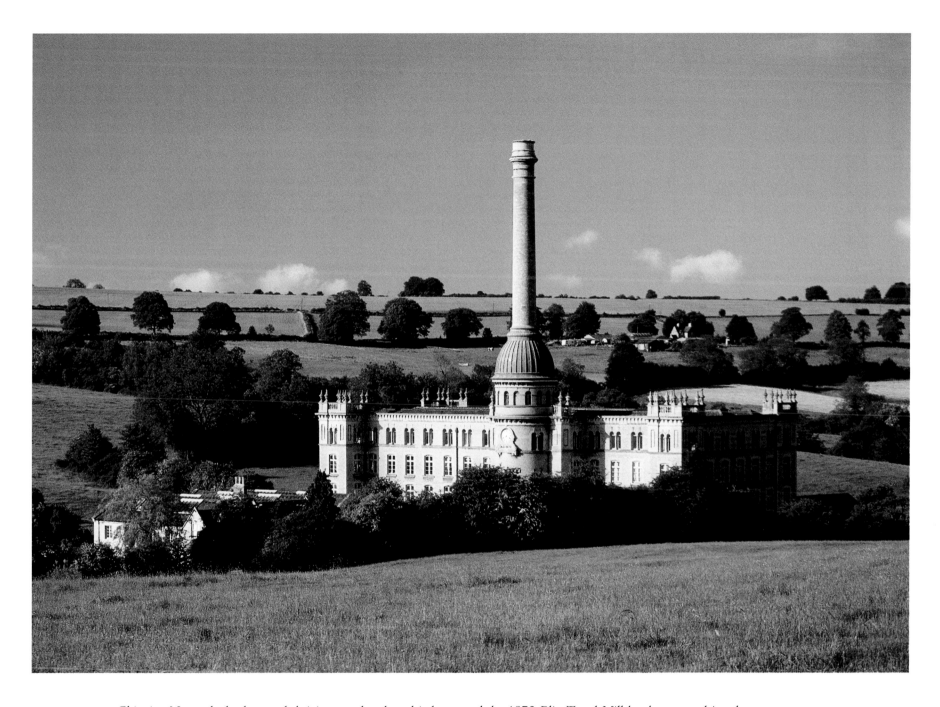

Chipping Norton had a long and thriving tweed and wool industry, and the 1872 Bliss Tweed Mill has been turned into luxury apartments

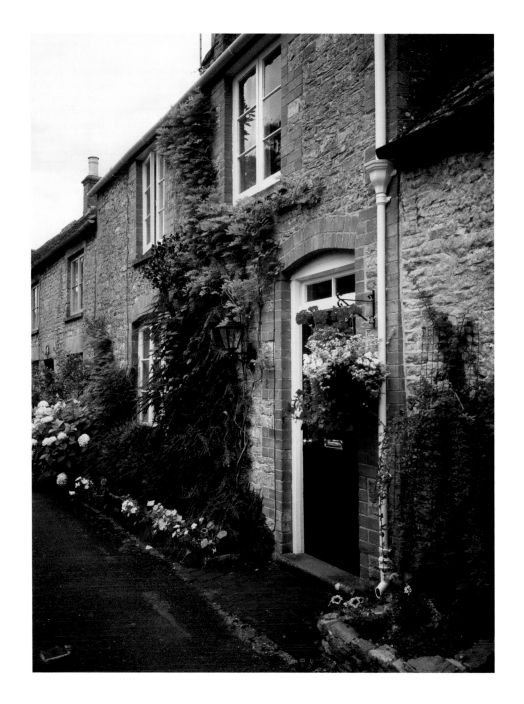

Local quarries provide the Cotswold stone for cottages in Stow-on-the-Wold

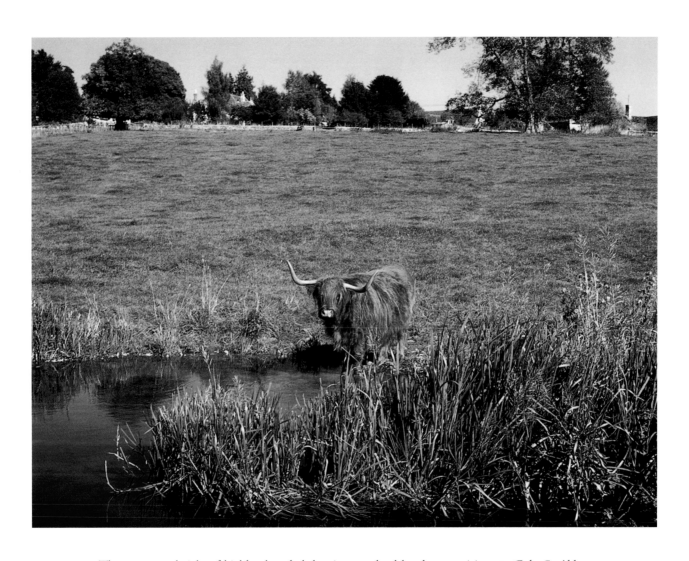

The unexpected sight of highland cattle belonging to a local hotel greets visitors to Coln St Aldwyn

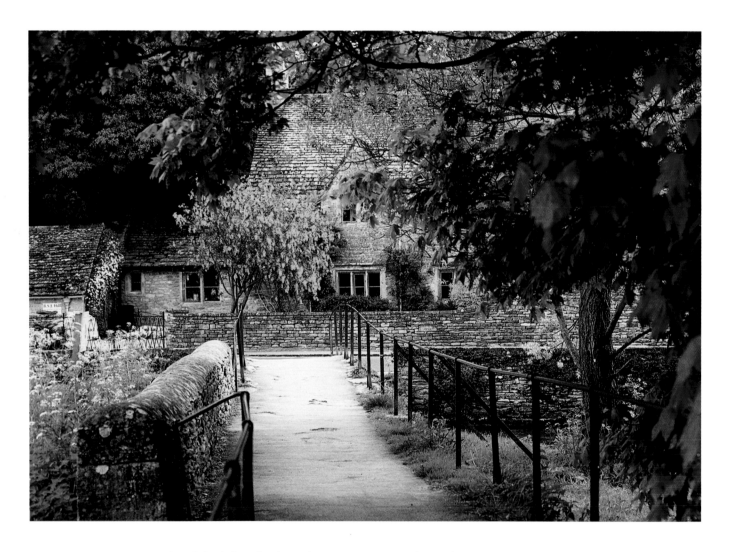

A path leads beguilingly to the weavers' cottages along Arlington Row in Bibury
Opposite: There has been a house on the site of Corsham Court near Chippenham since at least 978

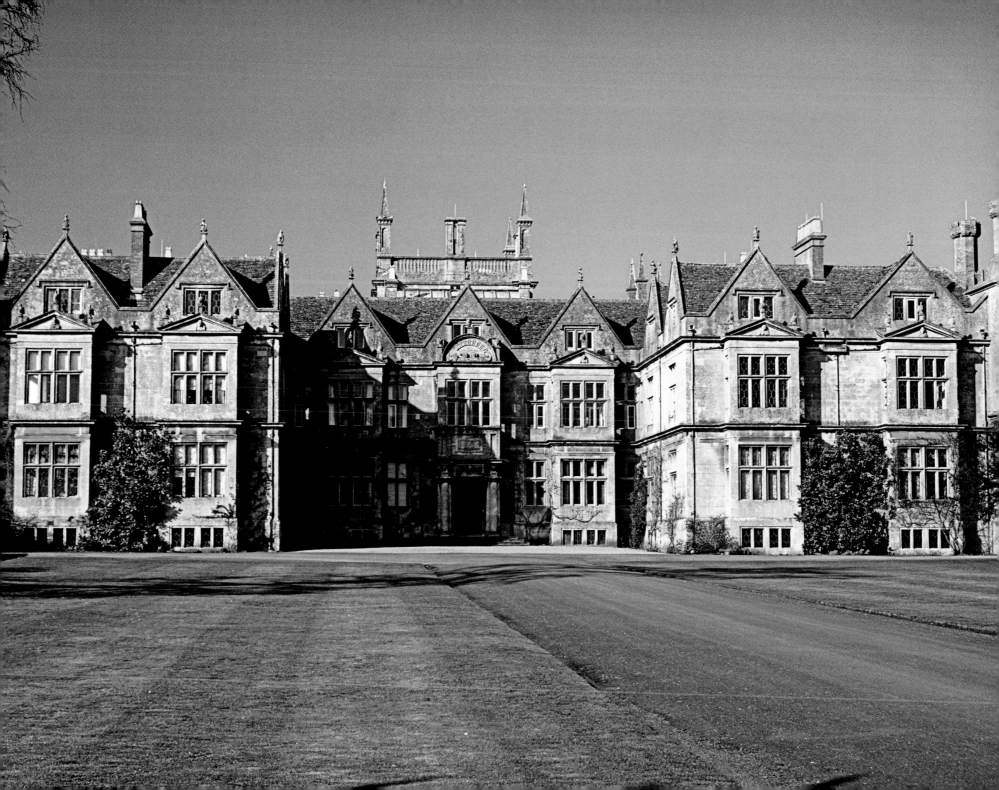

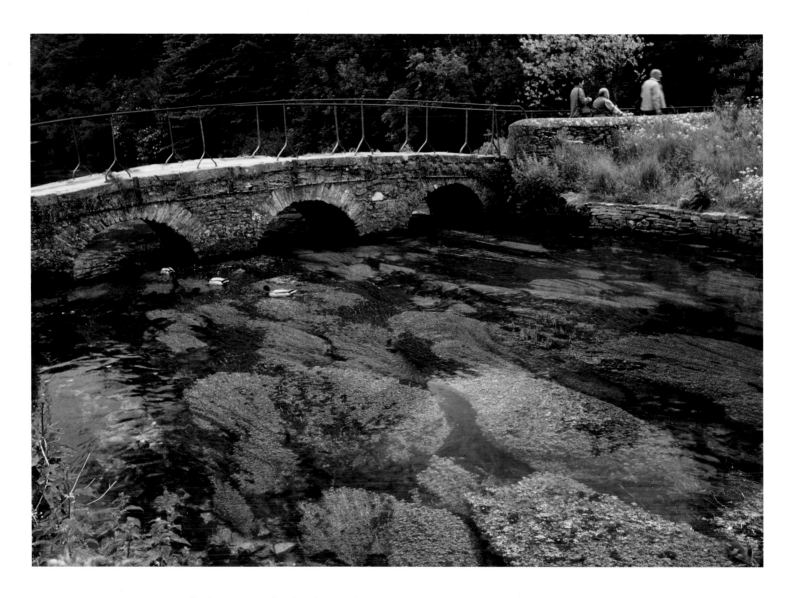

Mallards process under this three-arch bridge, which leads across the River Coln in Bibury

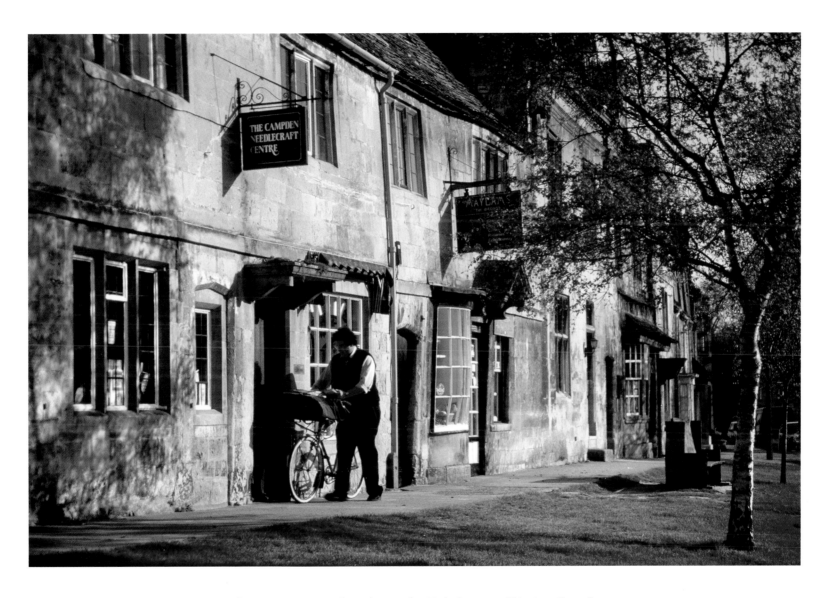

The post arrives on a lazy day on the High Street in Chipping Campden

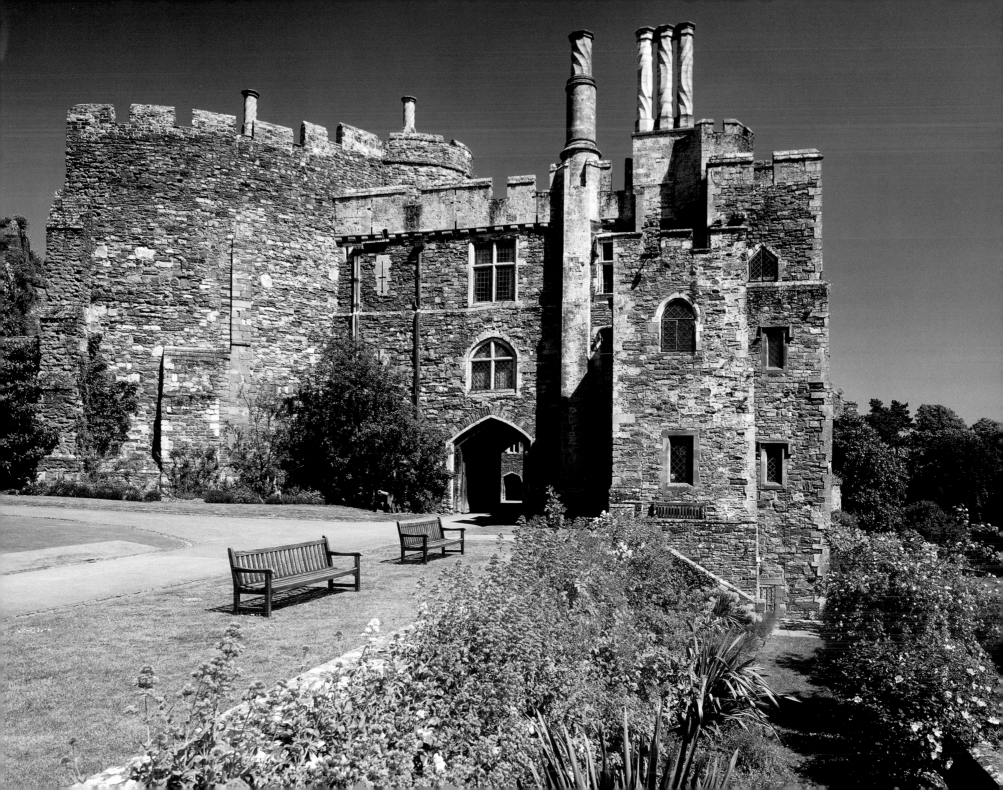

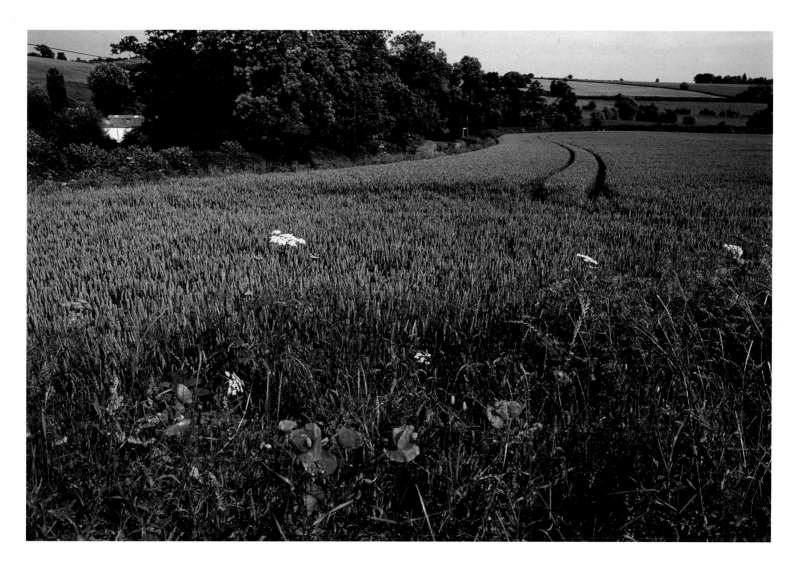

These poppies near the gatehouse of Broughton Castle show summer has almost arrived in the Cotswolds
Opposite: Berkeley Castle, where King Edward II was murdered, today sees more peaceful scenes

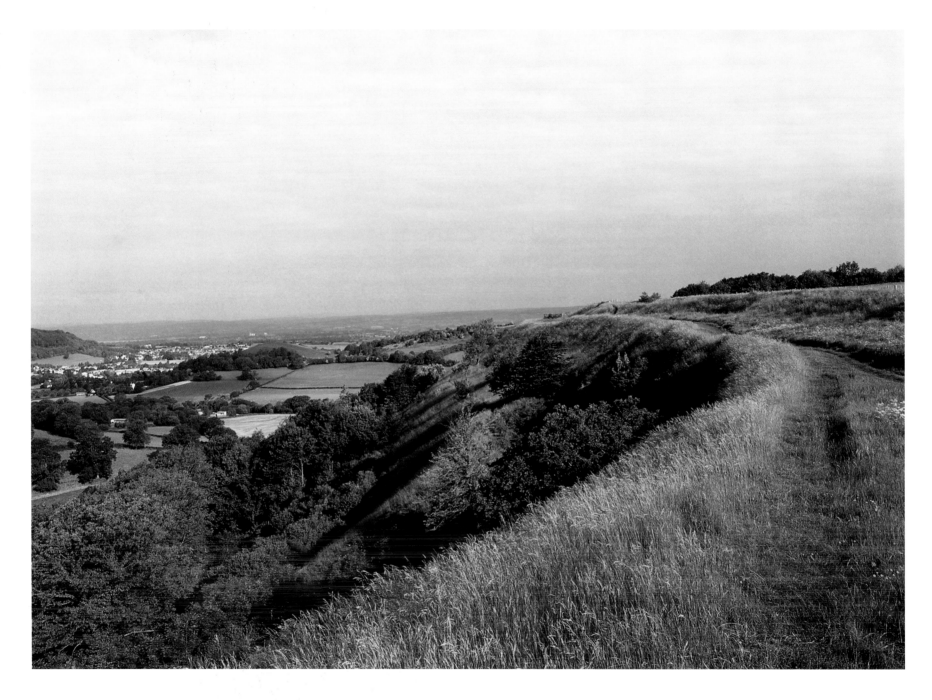

An Iron Age hill fort once stood at Uley Bury and dominated the surrounding area

No scene is more English than a thatched cottage in Chipping Campden

Ivy-covered steps lead down to the River Windrush at Bourton-on-the-Water

Opposite: Some steep streets lead down through Duntisbourne Abbots to the River Dunt below

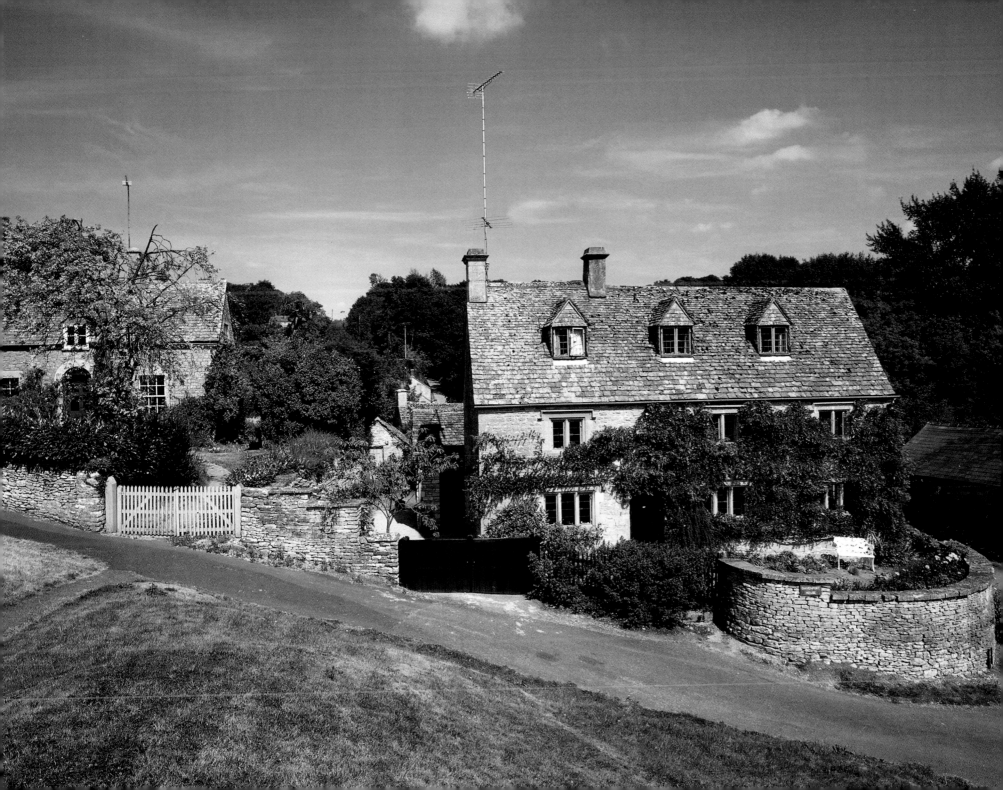

INDEX